IN REAL LIFE

SIX WOMEN PHOTOGRAPHERS

Leslie Sills

Holiday House/New York

For Charlie Steiner, who taught me so very long ago that work can be what I love. —L. S.

Acknowledgments

I want to thank Mary Cash and all the people at Holiday House for their support and enthusiasm for this project. Special thanks to Salomón Grimberg; Elizabeth Partridge of the Imogen Cunningham Trust; Elizabeth Partridge, children's book author; Manuel Alvarez Bravo Martinez; Carrie Mae Weems; Elsa Dorfman; and Cindy Sherman for their assistance, cooperation, and patience. I thank Bernice Speiser and Charlie Steiner for their editorial assistance. Thomas Lang's photographic expertise helped realize several chapters. Robert and Eric Oresick have been pivotal in their feedback and encouragement. Thanks, too, to Geraldine Churchill for her emotional support. And Elizabeth Harding, thank you for your kind words, helpful advice, and steadfast belief in me.

Photo credits:

Photographs *page 6,* Courtesy of the Museum of Modern Art, New York, Gift of Hermine M. Turner; *pages 7, 9, 10, 11, 12, 13, 15, 16, 17,* Courtesy of the Imogen Cunningham Trust; *pages 18, 21, 23, 29,* Courtesy of the Dorothea Lange Collection, The Oakland Museum, The City of Oakland, Gifts of Paul S. Taylor; *page 19,* Courtesy of Elizabeth Partridge; *pages 24–25,* Courtesy of the Library of Congress, Washington, D.C.; *page 27 (top),* Courtesy of the Museum of Modern Art, New York; *page 27 (bottom),* Courtesy of the National Archives, printed by Peter M. Coons, Inc., Washington, D.C.; *pages 30, 31, 32, 35, 36, 37, 38–39,* Courtesy of Lola Alvarez Bravo, copyright © 1995 Center for Creative Photography, University of Arizona Foundation; *pages 40, 41, 42–43, 44, 46, 47, 48, 49, 50,* Courtesy of Carrie Mae Weems; *pages 51 (top), 53, 56, 57, 58, 59, 60,* Courtesy of Elsa Dorfman; *page 51 (bottom),* Courtesy of "a mom"; *pages 62, 63, 65, 66, 67, 68, 69, 70,* Courtesy of Cindy Sherman.

Book design by Edward Miller
Diagram of camera, *page 72,* by Edward Miller

www.holidayhouse.com

Library of Congress Cataloging-in-Publication Data

Sills, Leslie.
 In real life: six women photographers / Leslie Sills.—1st ed.
 p. cm.
 Includes bibliographical references.
 ISBN 0-8234-1498-1 (hc.)
 ISBN 0-8234-1752-2 (pbk.)
 1. Women photographers—Biography. 2. Photography, Artistic. I. Title.
TR139 .S48 2000
770'.92'2—dc21
 [B] 99-051832

Contents

Introduction 4

Imogen Cunningham 7

Dorothea Lange 19

Lola Alvarez Bravo 31

Carrie Mae Weems 41

Elsa Dorfman 51

Cindy Sherman 63

To the Readers 72

Camera Basics 73

Bibliography 74

Index 78

Introduction

Photographs are *everywhere*—in books, magazines, newspapers, and on billboards. They are so much a part of our lives that we often don't think about them. They show us faraway places, things to buy, important people and happenings, and sometimes just the ordinary.

We also take our own photographs or snapshots. We record people, events, and places we want to remember: a special friend, a birthday party, a school play, the beach on a summer vacation. These pictures seem like frozen moments of real life. They can fool us into thinking that photography is mechanical and simple. "What you can see you can *photograph*" was an ad for a camera in 1928. It is a message many people continue to believe about all photography.

Photography, though, can be complex. While a photographer does use a mechanical tool, the camera, to capture an image, it is *how* and *why* it is done that can make a photograph art. When planning to photograph a person, for instance, the artist will decide what she wants to communicate. If she is interested in her subject's personality, she may encourage her subject to talk or laugh or engage in an expressive activity while she takes the picture. If, however, the artist wants to symbolize her subject's life circumstances, she may photograph only hands or shoes or hair ribbons. The background may be a white wall or a colorful flower garden. There may be sunlight, moonlight, or fluorescent light. A large 8-by-10-inch camera that clearly records details may be the best choice, or a small 35-millimeter camera that quickly captures action could work better. Some photographers work spontaneously, trying to catch the perfect instant. Others will carefully plan, take hundreds of photographs of the same subject, and show only the best one.

There are choices, too, in processing and printing film. One photographer may take the film to a laboratory and give instructions about how the finished work should look. Another may develop the film and print the photographs herself, experimenting with paper, textures, colors, and sizes.

Furthermore, even though the artist may try to plan every detail, her emotions, imagination, and values can unexpectedly affect the results. Holding the camera, the photographer must let her intuition and reflexes operate. She will not be able to see all the details in

front of the lens in the split second needed to press the shutter release. She will not know exactly what she has captured until the film is developed.

Imogen Cunningham, Dorothea Lange, Lola Alvarez Bravo, Carrie Mae Weems, Elsa Dorfman, and Cindy Sherman are artists who have used the camera in different ways and for different purposes. Imogen Cunningham liked to examine life closely. When she photographed nature, she focused on shapes, textures, and patterns. When she photographed people, she seemed to capture their essence. Dorothea Lange used the camera as an activist tool. Her photographs revealed the suffering of thousands of people and motivated others to help. Lola Alvarez Bravo recorded Mexico after the Mexican Revolution in the early twentieth century. Her work keeps alive a time and place that might have been forgotten. Carrie Mae Weems shows the complexities of being human, and particularly of being African American. Her work squelches stereotypes, honoring African-American culture. Elsa Dorfman celebrates humanity. With an oversized camera, she creates portraits that present her subjects in a natural manner, as they might appear every day. For Cindy Sherman, the camera is an instrument to copy her constructed scenes. Her photographs are puzzles that challenge her audience.

Learning about the work of these artists, one will see that photographs are not straightforward reflections of real life. Cameras do copy what is in front of the lens, and so, in that sense, photographs show what is real. They are simultaneously, however, creations of the artist's intentions and unconscious mind.

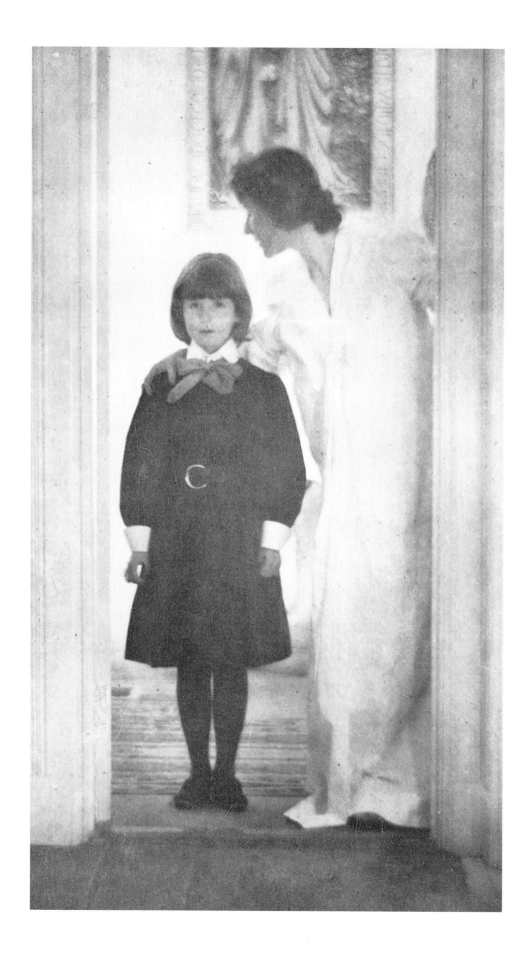

Imogen Cunningham

1883–1976

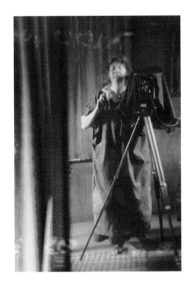

When Imogen Cunningham began to take photographs in the early twentieth century in America, photography had been invented only seventy years before. The first photographers used large, heavy cameras to record people and events. As small, handheld cameras became available to the general public, the idea that a camera mechanically records life was reinforced. Imogen, however, became interested in a group of artists who thought of photography as an art similar to painting, a way to express emotions. One photograph, in particular, influenced her. Gertrude Käsebier's *Blessed Art thou Among Women,* c. 1900, represented a new direction in photography. It shows a spiritlike woman tenderly greeting a young girl in a doorway. This carefully arranged scene and the emotions it evokes show that a photograph can be an artist's creation. Imogen would make this deliberate approach the basis of her work.

Opposite page: Gertrude Käsebier's *Blessed Art thou Among Women,* c. 1900
Top right: Untitled (Self Portrait with Camera), 1912

Imogen was born in Portland, Oregon, on April 12, 1883. The fifth of ten children, she was her father's favorite. Her father, Isaac, doted on her, teaching her how to read and arranging private art lessons on weekends and during summers. In her sophomore year at the University of Washington, Imogen decided to be a photographer, and Isaac gave her fifteen dollars to send for a camera from the American School of Art and Photography in Scranton, Pennsylvania. Although he thought photography was not worthy of his daughter's intelligence, he built her a darkroom in a section of their woodshed.

Imogen's first photographs were of her family, friends, and the land around her home and school. After classes, she made photographic slides for the botany department. She also studied the photographs of Edward S. Curtis, a well-known Seattle photographer who had done a series of photographic portraits of Native Americans. Following graduation, Imogen worked in the Curtis studio, printing his negatives.

In 1909, Imogen won a scholarship for further study from her college sorority. She traveled to Dresden, Germany, where she studied photographic chemistry, art history, figure drawing, and German. Her experience gave her a lifelong interest in German culture.

When she returned to Seattle in 1910, she started a portrait business. Her portraits were unusual for that time because she often used props, such as pets and flowers, and even photographed outdoors. She used the props to reveal the person's character, believing beauty is within.

At the same time, Imogen made more personal photographs for which she did not get paid. She often sent these to photographic magazines, such as *The Camera* and *Photographer's Association of America Annual,* which published them. In *The Wind, about 1910,* a woman, head and arms covered with a gauzelike wrap, stands outdoors, seemingly blown by the wind. She could be a spirit or a character from a poem or play. To Imogen, she represented the beauty in nature's forces.

In 1913, Imogen published an essay about women's and men's equality in the field of photography. That year, too, she began to correspond with Roi Partridge, an American artist living in Paris and friend of artists with whom Imogen had an adjoining studio. Imogen helped Roi arrange an exhibition of his work in the United States, and through their letters, they fell in love. Imogen and Roi wed in February 1915. Later that year their son Gryffyd was born.

The Wind, about 1910

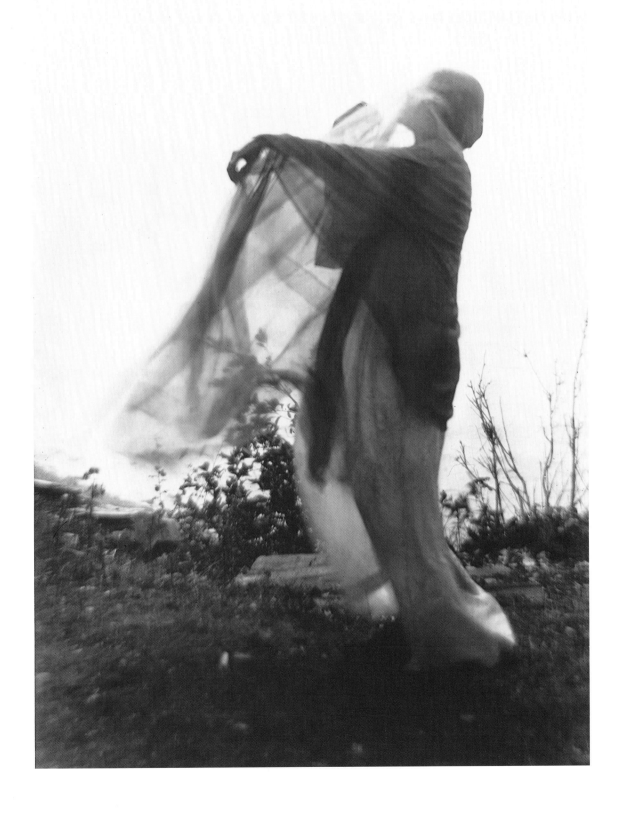

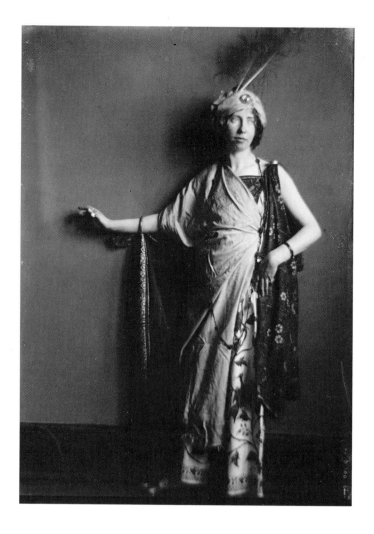

Imogen Play Acting in Javanese Costume, 1910s

Some of Imogen's most revolutionary photographs were of Roi. Traveling with him to the mountains, where Roi liked to sketch, Imogen photographed him nude in the wilderness. While images of nude women had been in paintings for centuries, nude men were considered too upsetting a subject. They had rarely been published in photographs. But Imogen's curiosity and vision drove her to experiment and to challenge society's expectations.

Working as a professional photographer while raising children was difficult, though. Roi often went on sketching trips and left Imogen to manage by herself. Left alone during her second pregnancy, Imogen moved the family to California, where her parents could help. Roi was initially furious, but eventually he took a teaching position at Mills College in Oakland to rejoin his family. There, in 1917, Imogen gave birth to twin sons, Rondal and Padriac.

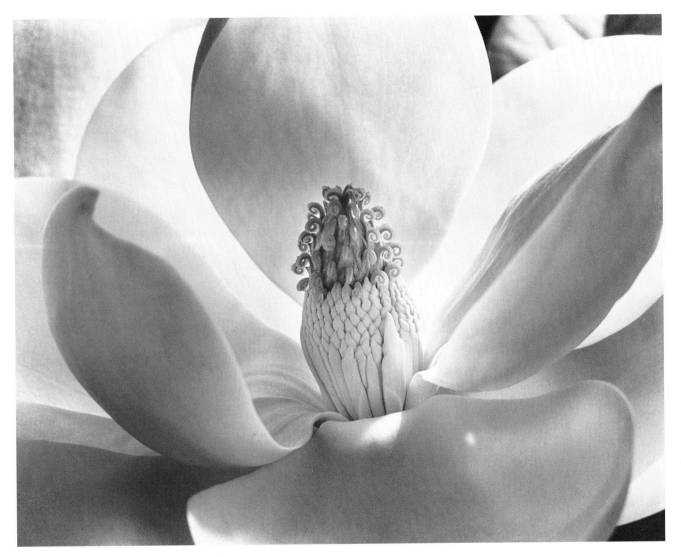

Magnolia Blossom, 1925

Although Imogen had little time for creative work, she still photographed her family and surroundings. Her garden became her major subject. Studying the forms, textures, and details of her beloved plants, she changed her style, transforming the soft, blurry appearance of her older photographs into clear, crisp images. *Magnolia Blossom, 1925,* is one of her most famous photographs. Imogen carefully controlled the light in this photograph to emphasize the petal shapes and interior form. While the photograph accurately shows the structure of the magnolia, it is much more than a study. It reflects the mysterious and spiritual nature of living things. Imogen took one hundred pictures of this flower before she chose this one to exhibit.

12

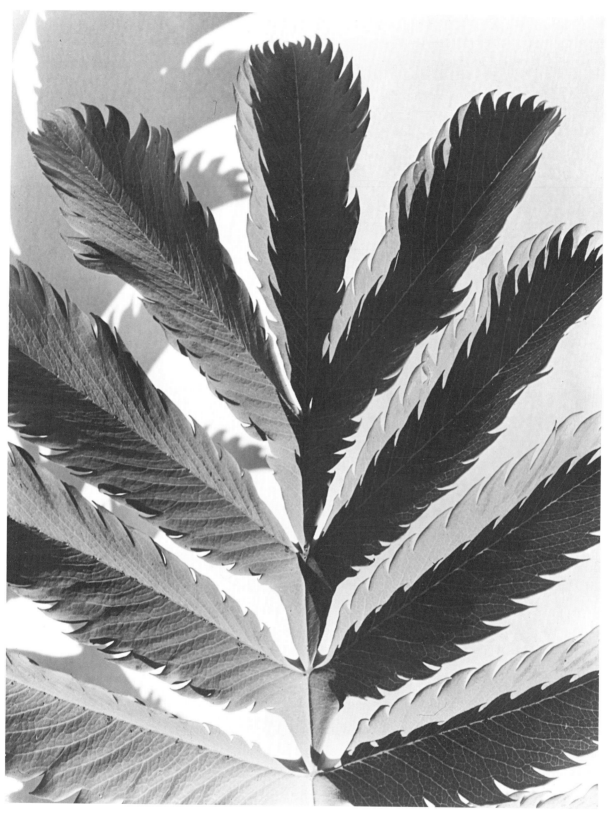

Leaf Pattern, Carmel Misson, before 1929

For *Leaf Pattern, Carmel Mission, before 1929,* Imogen again experimented with light. Here she arranged leaves to form a puzzlelike design. The strong contrast between light areas and dark shows Imogen's interest in patterns and her talent for revealing the elegant beauty of nature.

In 1929, Imogen exhibited ten of her flora pictures in *Film und Foto,* an international art exposition in Stuttgart, Germany. It was an honor to be included in the show, and it established her international reputation. Other exhibitions followed, but Imogen still had to struggle to make a living and take care of her children.

Luckily, she had many friends, including a young photographer named Dorothea Lange. Imogen socialized with Dorothea and her husband, Maynard Dixon, and met with other photographers as well to discuss their work and exchange ideas. These photographers called themselves Group f/64. The letter *f* refers to "f-stop"; f-stops are numbers on a camera that determine how much light is let in. The setting f/64 allows only a small amount of light. The resulting photograph is sharply focused with many distinct details.

Group f/64 thought such clear images were the most truthful way to show the world. They called their work straight photography because they did not use special lenses or alter the negative when printing. They considered their work an independent art form, not something to be compared with painting. Group f/64 greatly influenced later generations of photographers.

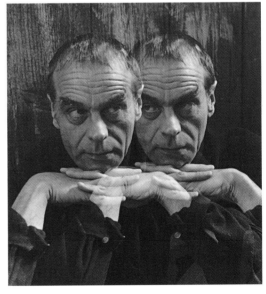

The Poet and His Alter Ego, 1962

While Imogen did sometimes work in a straightforward manner, she was too rebellious to follow anybody else's ways. She loved "to fool around," as she once said. Sometimes she blocked out areas of her pictures when printing, a process called cropping. Other times she kept "accidents"—for example, prints whose dark tones turned light and light tones dark when unintentionally exposed to surrounding light. She also liked to sandwich two negatives together and print them as one, as she did in *The Poet and His Alter Ego, 1962*. In this photograph she told her sitter "to look real

miserable to get at the poet in you." Imogen claimed that it was just luck that he moved his eyes when she took the second exposure. Imogen, though, had a great talent for capturing the essence of a person. She liked to say she "nailed" her subject.

Unfortunately, the Great Depression of 1929 hurt Imogen's portrait business. *Vanity Fair* magazine, however, then the leading publication on the arts and culture, invited Imogen to work in New York. When asked whom she wanted to photograph, Imogen replied half seriously, "ugly men." Her assigned subjects turned out to be some of the most important movie stars and politicians of the day.

Roi, who was busy with his work, wanted Imogen to wait to go to New York until they could go together. She couldn't. The children were grown and she was tired of putting her work and their family second to Roi's career. Imogen left for New York, and she and Roi divorced in 1934.

In New York, Imogen photographed Hollywood celebrities such as Cary Grant and Spencer Tracy, but she also took many spontaneous photographs on the streets, what she called "stolen pictures." She focused on people, carefully composing the shots, creating sharp images with rich tones. Many photographers were concerned with what their pictures meant, but Imogen cared mostly about *the way* she presented her ideas. Form, line, tone, and composition were always important to her. "There should be a little bit of beauty in everything," she said.

After a few months, Imogen returned to California but continued to work for *Vanity Fair* and other magazines. In 1934, Paul Taylor, a professor of economics at the University of California, Berkeley, asked Imogen and four other photographers, including her friend Dorothea Lange, to photograph unemployed men at a failed California sawmill. Imogen documented their difficult lives to illustrate Paul's reports on the effects of the Depression.

Imogen worked hard and lived frugally. She believed "to have real work is the only way to live." In 1947, Imogen moved to a hillside cottage in San Francisco. Surrounded by a lush garden with a voluminous palm tree, she would work there for the rest of her life.

People continued to fascinate her, "perhaps because people are always different, they are different every second," she said. One of her most unusual and powerful portraits is *Morris Graves, Painter, 1950.* Graves deeply cherished his privacy but allowed Imogen to photograph him for an entire day. Once imprisoned for refusing to fight in World War II, he now painted quiet, sensitive images of wounded birds. Imogen captured his sad, thoughtful look.

Morris Graves, Painter, 1950

His expression, the natural setting, and the dappled sunlight give the viewer the sense that Graves is connected to another, more spiritual place.

From 1947 to 1950, Imogen taught at the California School of Fine Arts. Although she was excellent at recognizing a good photograph, she found it difficult to educate others. She believed everyone needed to find his or her own way. "If you want help in photography," she said, "don't go to a famous photographer."

Gradually Imogen's personal work became more and more well known. She had many exhibitions in museums and galleries. She received awards, and films were made about her life. When she was in her seventies, her art finally provided enough income so that her commissioned portraits were no longer essential. Fame, though, was unimportant to Imogen. "I'm just a working woman," she said.

In 1970, at age eighty-seven, Imogen won a prestigious Guggenheim Fellowship to print her early negatives. After working on the project for a while, she decided to begin a book. Age was never an obstacle for her. She loved to experiment, to photograph new subjects, and to be with people of all ages.

At age ninety, Imogen began her book, *After Ninety,* a collection of portraits of people who are old yet filled with energy and enthusiasm. Imogen sought out all kinds of people and did not worry if they could pay her. One sitter, a farmer, was so appreciative that he

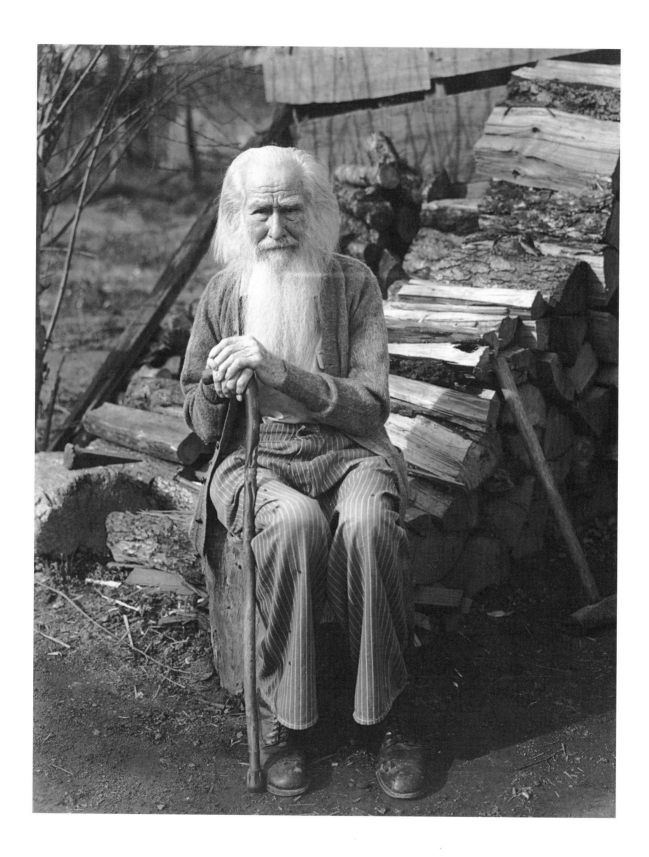

gave Imogen vegetables and a tray of raspberries. Imogen knew how much effort it took to harvest such a large number of raspberries and considered that payment enough.

My Father at Ninety, 1936, is a portrait of Imogen's father. Although taken many years before *After Ninety,* the photograph exhibits Imogen's idea of spirited old age. Here Isaac sits on his woodpile, with long white hair and a beard like Grandfather Time. Yet he sits tall and looks straight ahead, letting the viewer know he is still engaged in life.

Imogen Cunningham was a pioneer in photography. She advanced the medium in its early stages with her acute sense of beauty and design. She bounded ahead in her work—curious, adventurous, courageous, always ready to try something new yet never thinking she was unusual. Her portraits showed her involvement with her subjects. Using her skill and often her humor, she helped people relax, allowing her to capture their deepest selves. She was, in fact, such a special woman that, in 1970, the mayor of San Francisco declared November 12th Imogen Cunningham Day.

Even in her nineties, Imogen was exploring and celebrating old age in a culture that worships youth. When asked how she kept busy, she answered in her typical blunt way, "I don't keep busy. I am busy." After Imogen died on June 23, 1976, an enormous party was held at Golden Gate Park. People of all ages and backgrounds gathered to relish the moment, just as Imogen would have wanted.

Opposite page:
My Father at Ninety, 1936
Right: *My Three German Dolls, 1972*

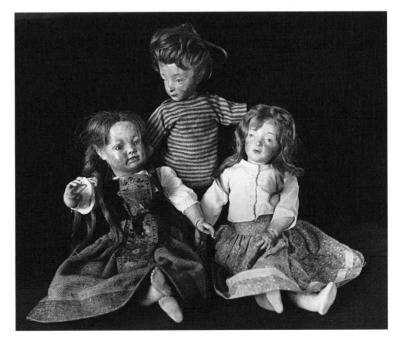

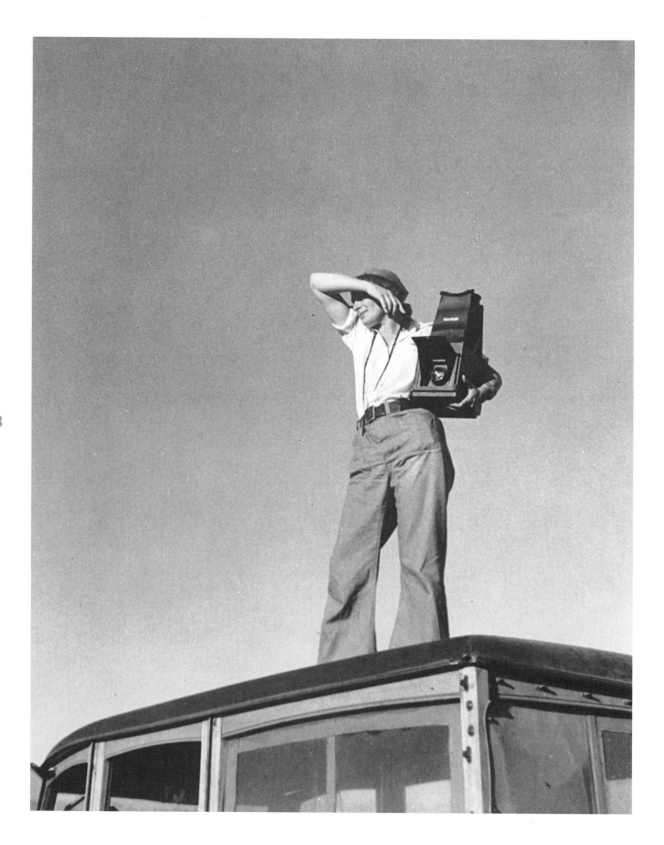

Dorothea Lange

1895–1965

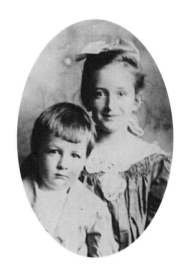

Dorothea Lange once said, "A camera is an instrument that teaches people how to see without a camera." She was committed to helping people in trouble. By photographing them, she hoped to awaken and inspire the more fortunate to help, too. That is why her pictures are called documentary, a word that comes from the Latin root *docere,* meaning "to teach."

Dorothea became passionate about helping people during the Great Depression, when one out of four Americans lost a job. She had a portrait business in San Francisco then, but outside her window she saw unemployed men lined up for free food. She thought these men were tremendously brave as they endured circumstances they could not control. She *had* to capture their feelings.

Photographing outdoors, Dorothea could catch the spontaneity of the moment. She did not want to intrude, however. What she discovered was that people felt comfortable with her. The unassuming way she presented herself and the fact that she was disabled perhaps made them see that she was not so different from themselves.

Dorothea was born Dorothea Margaretta Nutzhorn in Hoboken, New Jersey, on May 25, 1895. When she was seven, she contracted polio, a crippling disease that left her right

Opposite page: Untitled (Portrait on car roof with camera), 1934, by Paul S. Taylor
Top right: Untitled (Childhood photo, with brother, Martin)

leg thin and her foot inflexible. Children called her Limpy because of the unbalanced way she walked. Her mother would say, "Now walk as well as you can!" Although remarks like this hurt, Dorothea's disability reinforced her strong will and enabled her to understand the suffering of others. This understanding would become vital in her work as a photographer.

When Dorothea was twelve, her life changed dramatically again when her father, Henry, abandoned his family. No one knew where he went, and Dorothea never saw or spoke to him again. She was so sad and angry that she could not even mention his name until she was in her sixties.

Dorothea's mother, Joan, supported Dorothea and her younger brother, Martin, as a librarian on the Lower East Side of New York City. Dorothea traveled there with her every day to attend school nearby. Although she was a good student, she couldn't wait till the end of the school day when she could study pictures in the books at her mother's library. She loved all kinds of pictures and would spend hours looking at them. She also liked to stare out the windows at the people bustling by in the street. When her mother worked at night, Dorothea would return home alone and sometimes have to step over drunken men. She was afraid but felt confident she could protect herself. "If I don't want somebody to see me I can make the kind of face so eyes go off me," she said. She learned not to draw attention to herself, a skill she later used as a photographer.

By the time she was eighteen, Dorothea decided to be a photographer, even though she had never owned a camera. After graduating from high school, she worked in the studio of a famous portrait photographer, Arnold Genthe. She learned everything she could from him and then went on to other studios. She eagerly picked up as many skills as possible, including operating a large 8-by-10-inch camera, printing negatives, and even finding the best ways to get customers and, later, to bill them. She also studied for one year with a master photographer, Clarence White.

In 1918, Dorothea left New York to travel around the world with her grammar-school friend Florence, nicknamed Fronsie. Unfortunately, when they arrived in San Francisco, they were robbed. They had to find jobs to eat and pay rent. Dorothea worked in the photo-finishing department of a camera store. There she made many friends, including a wealthy businessman who offered to help her start her own portrait photography business. She accepted. Opening a studio on Sutter Street, Dorothea dropped her last name, Nutzhorn, and took her mother's maiden name, Lange. She was twenty-three.

Dorothea considered her work more a practical job than an artistic pursuit. But she was so skilled at it, she had as many customers as she wanted. In her portraits she carefully arranged her subjects, the setting, and lighting to emphasize the personality of her sitters. In *Untitled (Raentsh Portrait, SF)*, the shadows on the woman's face, her outward stare, her folded arms, and her leaning against the wall are elements that Dorothea deliberately chose to reveal this woman's thoughtful nature.

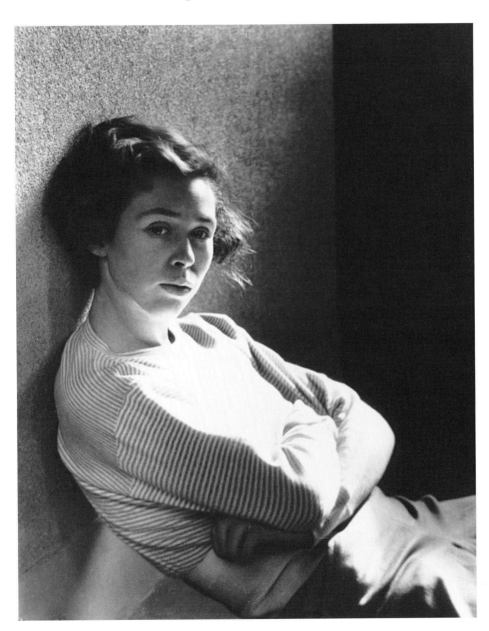

Untitled
(Raentsh
Portrait,
SF), 1932

Dorothea also liked to spend time with friends, talking about art or listening to jazz. One friend was a painter named Maynard Dixon. Dorothea and Maynard fell in love and married six months later. By 1928, they had two sons, Daniel and John.

On a vacation with her family in the Sierra Nevada, where she had been photographing the land, Dorothea sat on a mountain ledge, thinking about her life. A storm came up, and she suddenly realized that she wanted to photograph only people: "all kinds of people, people who paid me and people who didn't," she recalled. When she returned home, the Great Depression unexpectedly provided the opportunity.

From 1932 to 1934, Dorothea photographed many of the millions affected by America's poor economic conditions. During that time, people with jobs suffered because wages were low and hours long. Some protested, and in support, Dorothea photographed their demonstrations. When Franklin D. Roosevelt was elected president in 1933, he began programs to help protect Americans and to create jobs for the unemployed.

A year later, Dorothea exhibited her photographs publicly for the first time. Her show surprised people. They were not used to seeing photographs of social problems that provoked such strong emotions. Dorothea chose just the right person or people and setting to reflect the pain of many Americans.

One person who loved her work was an economics professor named Paul Taylor. Paul was doing research for President Roosevelt's Works Progress Administration (or WPA). He was trying to help poor Americans in rural areas by talking to them about their lives and then sending reports to the government. When he saw Dorothea's photographs, he knew his reports would be more effective if her work accompanied them. Dorothea liked his idea. She was hired by the government as a "typist," the only job slot available, and went with Paul on his field trips.

In 1934 and 1935, thousands of farmers from Kansas, Oklahoma, Texas, New Mexico, and Arkansas left their farms because a terrible drought had killed their crops. The soil was so dry and the wind so fierce that the area became known as the Dust Bowl. These farmers migrated to California, hoping to find better conditions, but there were far too many workers for the number of available jobs. As the Depression continued, the farms that were successful used machines—tractors and harvesters—instead of workers.

Dorothea and Paul worked tirelessly, speaking to the migrants and taking pictures. The conditions were shocking. As Untitled (Migrant Housing, California, c. 1936) shows, the migrants' homes were made of whatever they could find: canvas, cardboard, twigs, and even grasses woven between poles. In one report, Dorothea and Paul wrote, "Words cannot describe some of the conditions we saw."

When the government officials received the reports along with Dorothea's photographs, they understood the suffering. President Roosevelt responded quickly. He set up camps with tents and trailers and provided food and clean sanitary facilities. Dorothea's photographs were among the first in America to lead to government action.

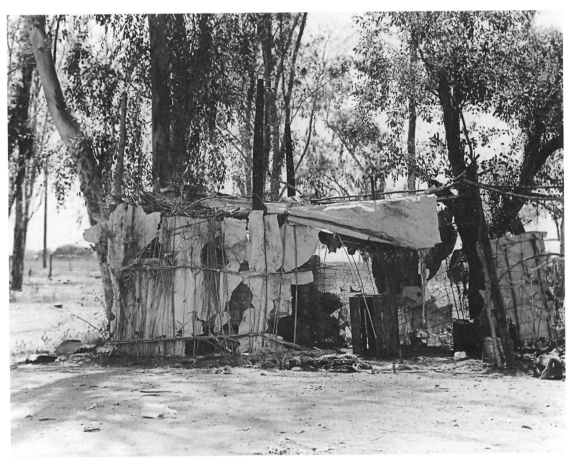

Untitled (Migrant Housing), California, c. 1936

In Real Life

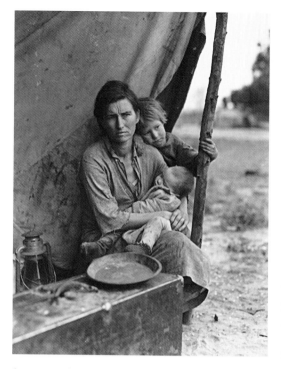

Migrant Mother, 1936, perhaps Dorothea's most famous photograph, was taken during this time. Dorothea had been photographing for weeks and was anxiously driving home alone in a rainstorm. She passed a sign that said Pea Pickers Camp but was too weary to stop. Twenty miles down the road, she felt she must return. She turned around and drove right in "like a homing pigeon," she recalled. There she found a rain-soaked woman trying to shelter her children. Along with twenty-five hundred men, women, and children in the camp, this family was trying to survive by eating common birds killed by the children and peas that had frozen on the vine. The family could not leave because the mother had had to sell their car tires to buy food.

Dorothea spent ten minutes taking photographs. She took six pictures, talking very little. She learned only that the migrant mother was thirty-two years old and that the father of her seven children was a native of California. Because Dorothea was unsteady on her feet but used a large, heavy camera, each photograph had to be planned quickly. Her first two photographs were taken from a distance and included a teenage daughter. With each following photograph, Dorothea moved in closer. While all the photos clearly portray the pain of this family's life, the last photograph, known as *Migrant Mother,* is the most powerful. Here the mother is the focus. She looks to the side with her hand held to her mouth as if she is in a state of despair. The children at her sides have turned their heads and are leaning on

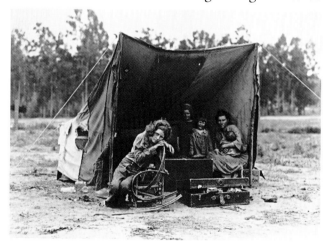

Migrant Mother, Nipomo, California, 1936 (series of three photos)

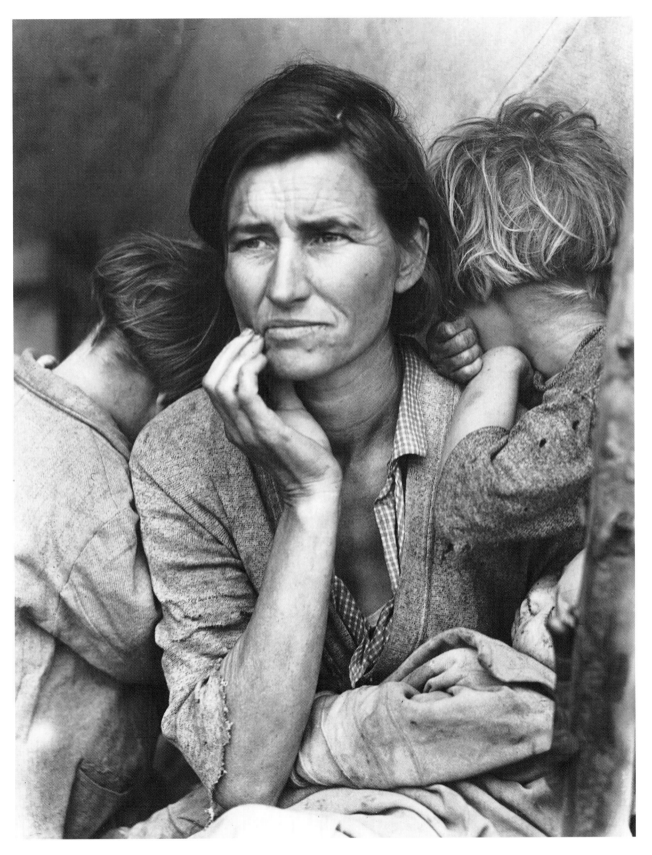

their mother as if for comfort. Perhaps Dorothea suggested this to avoid including the children's expressions, which she may have feared might compete with their mother's worried look. The baby sleeping on her mother's lap is dirty, further emphasizing their horrible conditions. This composition became a symbol for all suffering families of the Depression.

Dorothea drove straight home and rushed to develop and print the film. She quickly sent copies not only to the government but also to a San Francisco newspaper, which distributed them along with a story about the pea pickers to other newspapers. The alarmed United States government hurriedly sent the migrants twenty thousand pounds of food. *Migrant Mother* kept many people from starving.

Meanwhile, tensions had developed in Dorothea's marriage. Trying to balance the needs of the children with Maynard's career and her own had become impossible. Working with Paul, who shared her values and goals, Dorothea had fallen in love. Dorothea and Paul divorced their spouses, married, and joined families, which included five children. Dorothea's son Daniel was now ten and John, seven. Paul's children were Katherine, thirteen years old; Ross, ten; and Margot, six.

Dorothea, now in her forties, still faced many difficulties. Although she was dedicated to her work, Paul and she agreed that she would manage the house and children. She was so fussy about keeping order that the children nicknamed her Dictator Dot. When she traveled, she sent the five children to three different families of people they knew. The children were not happy with this arrangement, but Paul and she would gather them together on the weekends for dinner or a movie. Still, Dorothea felt torn between her career and motherhood. She also developed a severe stomach ulcer that required several operations and prevented her from working for three years. She was always in some pain for the rest of her life.

When she felt well enough, Dorothea continued to photograph "all kinds of people." She traveled with Paul throughout the rural United States, documenting hard lives. *Sharecroppers, Eutaw, Alabama,* 1937, shows an African-American family hoeing the land. The parents and all five children, ages seven through fourteen, had to work together in order to earn a total of $150 a year, barely enough for them to survive. These people were sharecroppers, some of the nine million Americans, of many races, who were too poor to own land. Instead they paid wealthy landowners 50 percent of everything they grew for the right to raise crops. Often cheated, these sharecroppers found it nearly impossible to save money to move on to better circumstances.

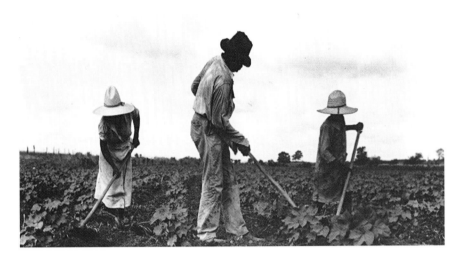

*Sharecroppers,
Eutaw, Alabama,
1937*

Photographing rural Americans and educating others about their suffering remained Dorothea's main concern even after the Depression. In March 1941, Dorothea became the first woman photographer, and only the third photographer ever, to be honored with the prestigious Guggenheim Fellowship. This award, given to artists who have consistently produced exceptional work for many years, provided her with ample funds for her next project. She planned to photograph the religious communities of the West. However, in December of that year, the Japanese bombed the American naval base at Pearl Harbor. The U.S. government became so fearful that it forced all Japanese Americans who lived on the West Coast—112,000 people—into internment camps surrounded by barbed wire.

The government hired Dorothea to photograph this evacuation. *May 8, 1942, Hayward, California* shows the Mochida family waiting for the evacuation bus, wearing tags as if they are luggage. The parents, who ran a plant nursery, appear calm. The children,

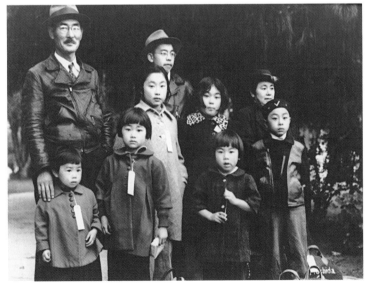

*May 8, 1942,
Hayward, California*

however, look worried and perhaps were wondering what was going to happen to them. Dorothea captured their dignity. The government, though, filed away her photographs of forcibly displaced Japanese Americans for thirty years. In 1972, they were finally exhibited publicly, traveling from the Whitney Museum of American Art in New York City to the Corcoran Gallery in Washington, D.C., the De Young Memorial Museum in San Francisco, and a Tokyo department store.

As the years passed, Dorothea's health deteriorated, preventing her from traveling and working. On her last trips, she visited Ireland for *Life* magazine and then Latin America, Egypt, and Asia with Paul. In Untitled (Korean Child), 1958, Dorothea focused closely on the face of a young Korean. When printing, she cropped the photograph to further emphasize the child's features: the softly rounded face, the wide forehead, the gently closed eyes and mouth. Although the photograph is of one child during one moment in time, it also reflects the beauty and innocence of all children.

Dorothea's own children and grandchildren also became her subjects. With tensions in the distant past, Dorothea vacationed with her family on the California coast, where she documented their friendships. A warm, close-knit family, something Dorothea never knew as a child, had become most important to her.

In 1964, when Dorothea was sixty-nine, she was diagnosed with terminal cancer. Knowing that she did not have long to live, she worked even harder. In her last months, she made a series of photographs on American farm women. She also helped produce two television films about her life, started a national project to organize young photographers to document American city life, and helped plan a one-woman exhibition of her art for the Museum of Modern Art in New York City.

Dorothea Lange's work awakened the world to the suffering of thousands of Americans. Using her camera as a tool, she portrayed social problems but maintained a great respect for individuals, their families, and their communities. In the face of one person, she was able to show the troubles of a nation. Her photographs made social problems impossible to ignore. Dorothea Lange died peacefully, surrounded by her family, on October 11, 1965. Her work is a great tribute to the endurance of the human spirit.

Untitled (Korean Child), 1958

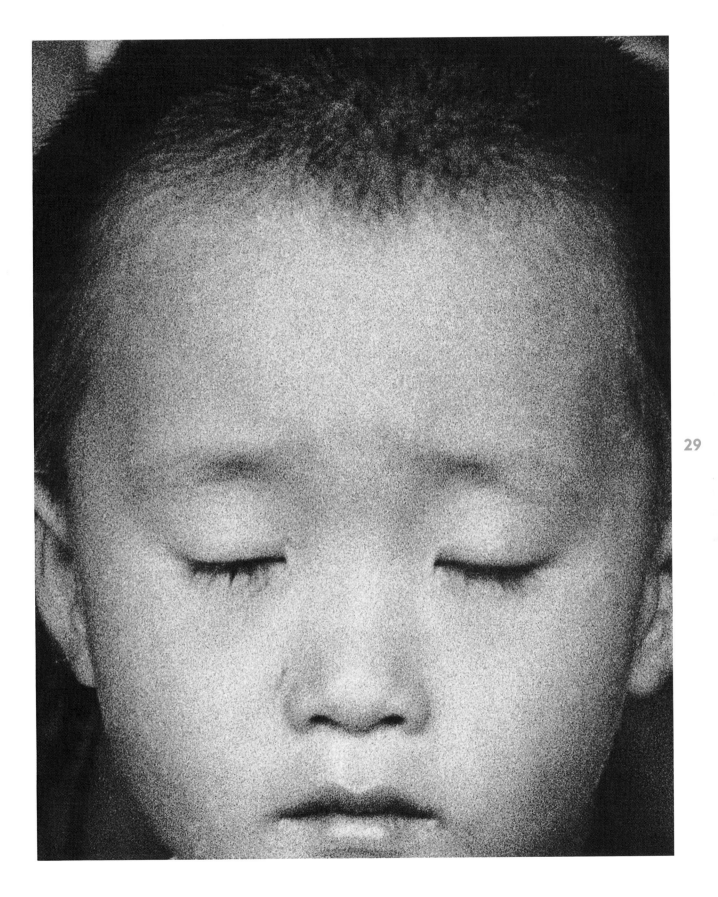

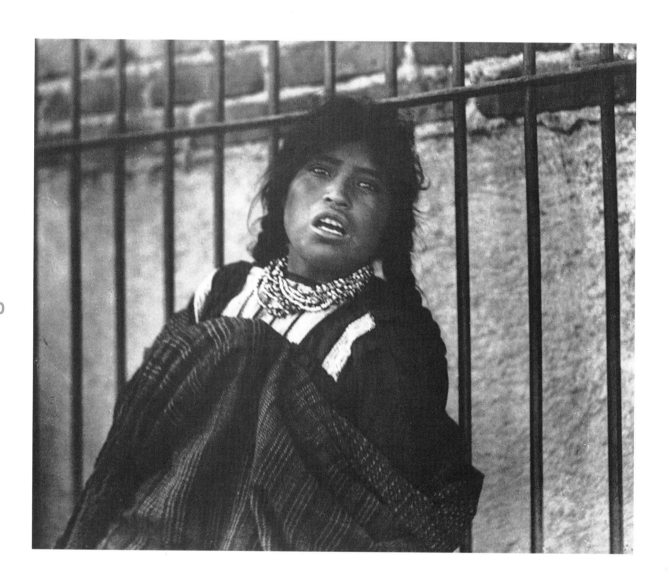

Lola Alvarez Bravo

1907–1993

"If my photographs have any meaning," said Lola Alvarez Bravo, "it's that they stand for a Mexico that once existed." Through her work as a photojournalist, commercial photographer, portraitist, and recorder of art, Lola captured the land, people, and customs of Mexico following the bloody Mexican Revolution of 1910, in which Mexican peasants fought for their rights. Many of Lola's photographs show the war's victims, whom she called "the injured part of Mexico." In *Por culpas ajenas* (*Due to the Fault of Others*), a Mexican woman huddles against a railed fence, mouth open, eyes fixed in a piercing stare. She seems crazed, as if she has just witnessed some unspeakable act. At the same time, she is pleading for help. "I never wanted to photograph to criticize people," Lola said, "only with love, to show they lacked attention and care."

Top right: Untitled (Self Portrait)
Opposite page: *Por culpas ajenas (Due to the Fault of Others)*, c. 1945

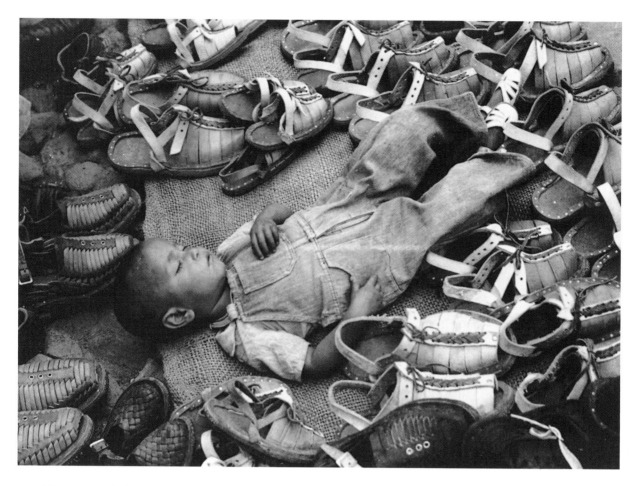

El sueño de los pobres 2 (The Dream of the Poor 2), 1949

Another photograph that shows Lola's caring is *El sueño de los pobres 2* (*The Dream of the Poor 2*). In this photograph, a boy sleeps in an outdoor market surrounded by *huarachitos,* or sandals. "A rich boy would dream of cake and candy, but a poor child of *huarachitos,*" Lola explained.

Perhaps Lola was sensitive to other people because of the losses she experienced as a child. She was born Dolores Martínez de Anda on April 3, 1907, in the small, rural Mexican town of Lagos de Moreno. Her mother died of an illness when Lola was two. At seven, Lola was traveling with her father on a train when he had a heart attack and died. Both her parents had been loving and made Lola feel special. After her parents' deaths, however, Lola and her brother lived with an indifferent older half brother, her father's son by a previous marriage.

Lola's half brother and his wife expected Lola "to study what would help a lady at home, entertaining and tending to her husband," Lola remembered. They wanted her to study the piano, sew, and cook, but she refused. "I wanted to find something useful in which I could be myself," said Lola.

At age twelve, Lola met Manuel Alvarez Bravo, a boy who lived in the same apartment building in Mexico City, where she had moved. They often played and roamed the streets together. They found the city beautiful despite its filth and poverty. A few years later, Manuel learned about photography from a schoolmate's father and began an intense interest that would alter his and Lola's lives.

By 1924, when Lola was seventeen, she and Manuel had fallen in love. They married the following year and moved to the country, to Oaxaca in the south of Mexico, where they lived happily for the next three years.

In Oaxaca, Lola found Manuel's fervor for photography contagious. She and Manuel shared a camera and darkroom and took pictures of each other, as well as of people in the countryside and Mexico City. Although Manuel taught Lola technical processes, he did not tell her what to photograph. "He has his style and I have mine," Lola once said.

Still, there were struggles. When Lola wanted her turn with the camera, Manuel became impatient. He also often expected Lola to develop and print *his* pictures. Lola, who was not confident of her abilities as a photographer and had been raised to be a supportive wife, went along with Manuel's demands.

In 1927, Lola and Manuel moved back to Mexico City for the birth of their son, also named Manuel. Soon afterward, Lola's husband left his job as paymaster at the National Accounting Office and, with Lola's help, began his career as a photographer. Together they opened a gallery in their home, where they exhibited photographs and paintings by friends. Among their friends were David Alfaro Siqueiros, Diego Rivera, and José Clemente Orozco, some of the most influential artists of the day. Today, they are prominent figures in the history of Mexico.

Lola's friendships with these artists became an important part of her education. She studied their art, training her eyes to understand how powerfully paintings can be constructed. Years later, when she was an established photographer, she said, "I came out a photographer because I knew about painting, composition, and the handling of light."

Lola, now known professionally as Lola Alvarez Bravo, tired of Manuel's bossy ways. In 1934, she left Manuel, taking their young son to live in the house of an artist friend until she could get settled. In 1948, Lola and Manuel divorced. Lola enjoyed her independence yet continued to love Manuel. When she was eighty-two years old, Lola said, "For me, love is like color, it has primary color and many shades. For me there has been only one primary love and that was Manuel Alvarez Bravo."

Immediately after her separation from Manuel, Lola taught drawing in elementary school. One year later, an official for the Department of Education asked her to do an inventory of government photographs. She had begun the work when the Minister of Education unexpectedly came to visit and she was asked to photograph him. "I was trembling," she recalled. "Two friends had to hold my arms. I honestly believed I couldn't do anything, and that's how I started."

Lola's photographs were such a success that she became chief photographer for a monthly educational magazine called *El Maestro Rural* (*The Country Teacher*). To illustrate the magazine's articles, Lola took hundreds of pictures in schools, factories, farms, orphanages, fire stations, and hospitals all over Mexico. She even combined photographs to make collages called photomontages, a technique used since the 1800s. Lola explained, "Sometimes I wanted to say something, and photography didn't fully allow me to do it. So I'd take a sheet of cardboard, make a drawing, select the negatives, print them the necessary size, then cut and paste." *Anarquía arquitectónica de la ciudad de Mexico* (*Architectural Anarchy of Mexico City*) is one of Lola's bold photomontages. Here the city's skyscrapers are crowded together and overlapping. Lola's composition shows how fast and overwhelmingly large she thought the city would grow. Many of her photomontages were used on the magazine's covers.

Lola's work for *El Maestro Rural* led to other photojournalism assignments. Lola was the only woman photographer to cover the tours of government officials. Although Mexican women were then expected to behave in traditional "ladylike" ways, Lola was not intimidated by physical challenges. She climbed oil derricks, flew in run-down planes, and even rode mules to remote places. Sometimes she was teased by her male colleagues. "I was the only woman fooling around with a camera on the streets," she recalled, "and the reporters laughed at me. So I became a fighter."

Anarquía arquitectónica de la ciudad de Mexico
(Architectural Anarchy of Mexico City), c. 1953

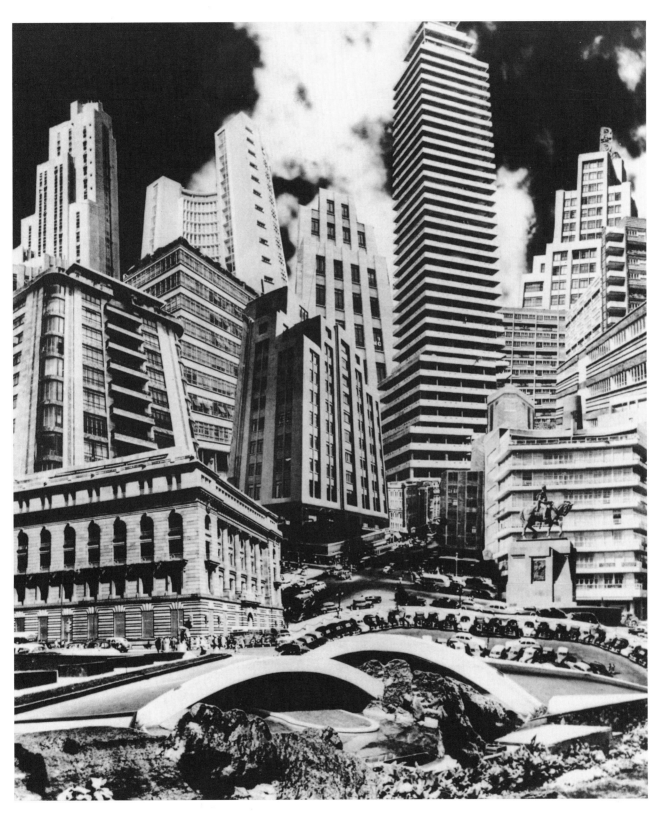

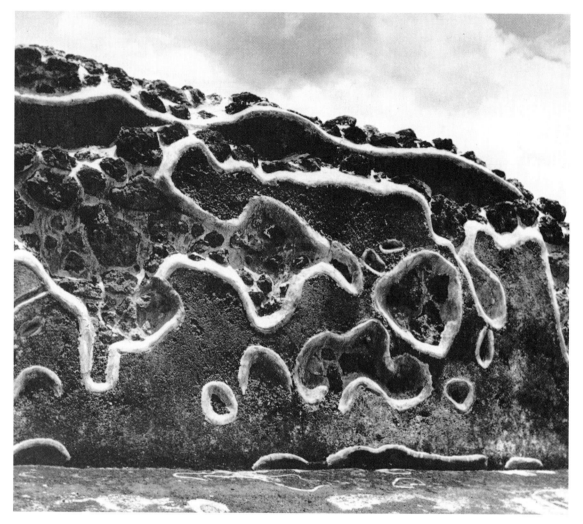

Paisaje fabricado (Man Made Landscape), 1951

By 1937, Lola was also working for the National University of Mexico, recording archae-
ological sites and certain regions of the country. *Paisaje fabricado* (*Man Made Landscape*) is a
decorative wall made of volcanic rock. It was built in the 1930s in an area called Teotihuacán.
Lola photographed this strange structure as though she were a tiny creature looking up at
a mountain. Her vantage point emphasizes the monumental, curved shape and the carved
openings studded with rocks reminiscent of jewels.

Lola took photographs for various government agencies for the next thirty-five years, until
1972. She also worked as a commercial photographer, doing fashion and advertising photog-
raphy. Between assignments, she took pictures of artist friends, colleagues, and their work.

One painter who meant a great deal to Lola was Frida Kahlo. "To me she was like birds and flowers and knitted quilts, a Mexican mood concentrated in an epoch and all expressed through her," Lola explained. Frida often painted herself to express her thoughts and

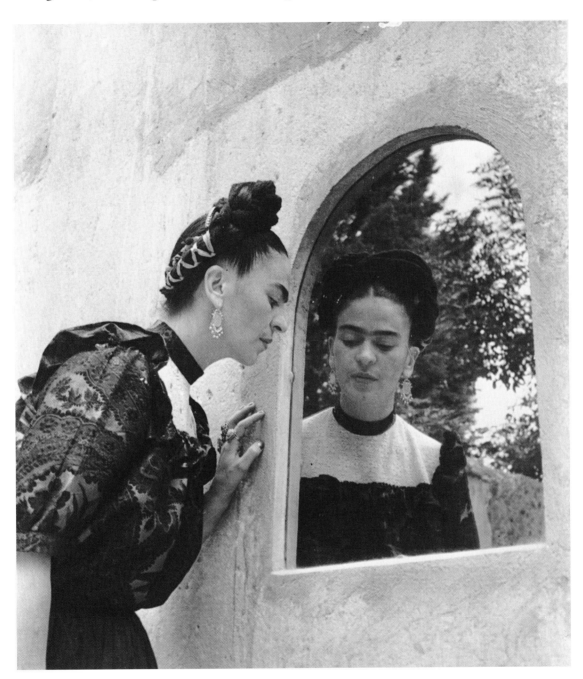

The Two Fridas, c. 1944

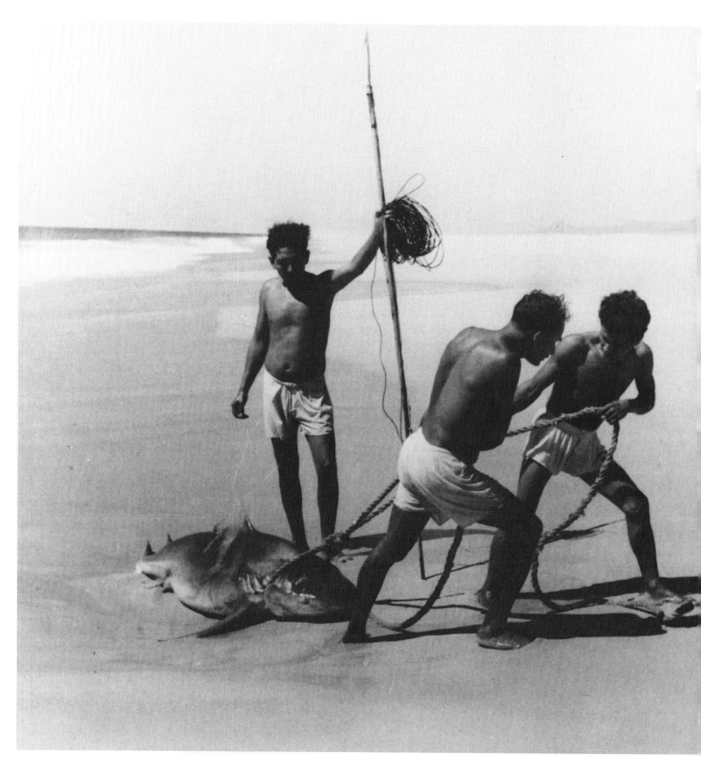

Tiburoneros (Shark Fishermen), 1950

feelings. She felt like two people. On the outside she was a beautiful, happy woman who liked to dress up in traditional Mexican costumes and be with friends. On the inside, she was a sad, lonely person, suffering from a troubled marriage and the lasting effects of a painful, crippling accident. When Lola created *The Two Fridas,* c. 1944, she used a mirror to show Frida's two sides. "I didn't lead her to [the mirror]," said Lola. "She approached it and I said 'closer.' Suddenly I saw the mirror and I said yes, two Fridas."

Lola went on to become the director of photography at Mexico's National Institute of Fine Arts. She also arranged traveling exhibitions, which brought art to people in isolated areas. She opened an art gallery in Mexico City in 1951, where she gave Frida Kahlo her only solo exhibition in Mexico. And as she promoted and taught about Mexican art, she exhibited her own work, too. *Tiburoneros* (*Shark Fishermen*) shows three men in bathing suits, their skin glistening in the sun, dragging their catch along a deserted beach. Lola took this photograph in Acapulco, a seaport that is now a densely populated resort. Lola's picture, however, with its spare composition and soft tones, has a primitive feeling.

Lola Alvarez Bravo was an active, forthright woman who fought to make her way in the world. As a survivor of personal tragedy and a female artist in a field dominated by men and considered physically dangerous, Lola set an example for later generations of Mexican women artists. A dedicated teacher and gallery director, she promoted the arts of Mexico, celebrating its culture. For five decades, until age seventy-nine when she lost her sight, Lola created thousands of crisp, sensuous images of a Mexico one could not see today. When asked, though, what she photographed, Lola humbly replied, "Nothing, no more than what life puts in front of me." Lola Alvarez Bravo died on July 31, 1993, leaving behind a great gift—her vision of Mexico.

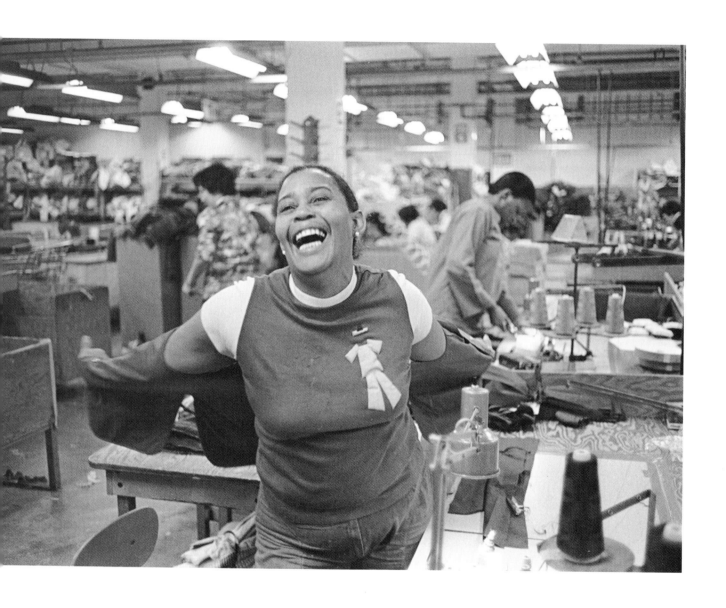

Above: *Mom at Work*, from "Family Pictures and Stories," 1978–84

Top right: Portrait

Carrie Mae Weems

1953–

In Carrie Mae Weems's photograph *Mom at Work,* Carrie's mother, who is at her factory job, enthusiastically greets her daughter. She is not posing for the camera. She is thrilled to see Carrie and throws back her arms in excitement. With a huge smile and ready embrace for her daughter, Carrie's mother bursts with intense love for her child.

Mom at Work is one photograph in Carrie's series called "Family Pictures and Stories." In all the photographs from this series, Carrie presents her family casually: at work, in their kitchen, living room, bedroom, or at the beach. Her photographs allow viewers to learn for themselves about Carrie's mother, father, three sisters, and three brothers and her relationships with them. Sometimes Carrie writes beneath her photographs to expand the viewer's understanding of these people. Under *Vera and Van with Kids in the Kitchen,* Carrie writes: "It amazes me that even in the midst of a bunch of crazy wild kids, my sisters [Vera and Van] still manage to carry on a half-way decent conversation. I'm really impressed."

In addition to the photographs and text, Carrie creates audiotapes that play when

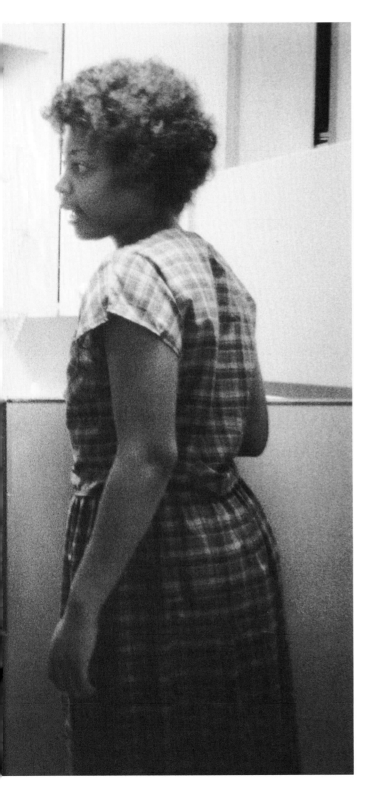

these pictures are exhibited. On the tapes Carrie tells stories about her family's past, of grandparents and great-grandparents, of struggles to survive, of difficult relationships and love. "But hook or crook, my grandfather, Frank Weems, was determined to make a life for his wife Vera and their 8 children. . . . For a black man, in the South, in the 1920's, being determined translates into being nothing short of a kind of hero."

Carrie does not hide her family's painful times. She has interviewed her mother, father, sisters, and cousins to learn everything she can about her family's history. Carrie's father told her, "One night my daddy left going to one of his meetings, but didn't make it. Everybody thought the white folks had gotten hold of him for sure. Maybe they tried, but way after while, he made contact with the family and let us know he was safe and living in Chicago. He asked Momma to come on to Chicago with us, but for some reason she just didn't want to go. Maybe, she was scared. Ya know a lots of people were afraid to leave where they was born. He stayed in touch. He's send money and clothes, and he always would write Momma. But she wouldn't leave Memphis."

Vera and Van with Kids in the Kitchen, from "Family Pictures and Stories," 1978–84

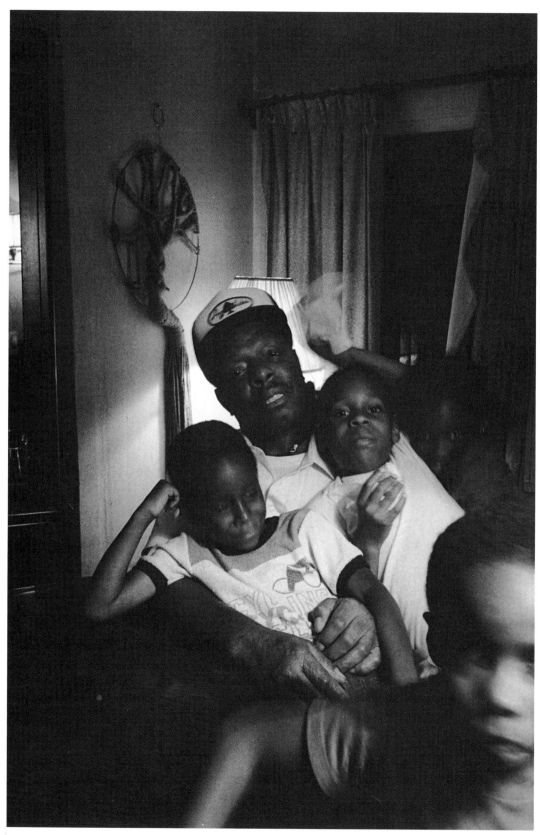

Daddy with Kids, 1982–84

With "Family Pictures and Stories," Carrie reveals how complex lives can be. She is particularly interested in African-American families, who, like her own family, have escaped the slavery-like sharecropping system of the South. Carrie, as a photographer, observes life intensely, just as she had as a child.

Carrie was born in Portland, Oregon, on April 20, 1953. She was a gifted student. Not only smart, she was not afraid to speak her mind. She also excelled at dance. "I always pretended I was a ballerina twirling around my house," she remembers.

At twenty-three, she had already worked professionally as a dancer and in restaurants, farms, factories, and offices when a friend gave her a camera to photograph a political demonstration. Shortly after that, she saw a book called *The Black Photographers Annual* and was stunned. She said, "Another world was opened about what photography could be about. It was the first time that I saw images of black people that seemed to describe something that was truer about them than anything else I'd seen."

Carrie liked the photographs in this book because they avoided stereotypes and showed black people as individuals, people with complicated emotions. The photographs taken by one man, Roy DeCarava, particularly impressed her. He recorded everyday life in Harlem, New York City, the most famous African-American community. Using soft tones of grays and blacks, he celebrated the beauty and richness of his culture. Carrie saw that photographs such as DeCarava's presented blacks with a strong sense of pride and dignity.

Now Carrie knew what she wanted to do. She began taking photographs of her family in Portland and of people on her travels to New York, Mexico, Fiji, and Southern California. Using a 35-mm camera (35 mm refers to the width of the roll of film, 35 millimeters), she recorded the everyday experiences of African Americans, such as girls on a bus, children going to school, a mother with a child resting on her hip, and a man at work. Carrie's photographs, like Dorothea Lange's, documented lives and educated the public.

In 1979, at age twenty-seven, Carrie entered the California Institute of the Arts, where she began "Family Pictures and Stories." After receiving her degree in 1981, she went to graduate school to study photography at the University of California in San Diego, graduating in 1984.

That year Carrie's interest in people led her to study folklore at the University of California in Berkeley. Carrie was attracted to the humor in folklore. She liked how jokes were used to reveal deep thoughts and attitudes that would be unacceptable if said directly. Folklore, Carrie believes, tells "real facts about real people." She wanted her

photographs, like folklore, to point to the unmentionable, such as racist stereotyping. By photographing the experiences and emotional lives of African Americans, she was confident she could portray the most truthful picture of their history.

The work of African-American author and folklorist Zora Neale Hurston also influenced her. Carrie learned from Hurston not only about "the deepness and the richness of the Afro-American culture," but also about the importance of being able "to pick it up, look at it, laugh at it, criticize, and really grapple with it." After reading Hurston's work, Carrie knew she could say whatever she wanted about the lives of African Americans in whatever way she chose: with photographs of people, places, or things, accompanied by words, sound, or objects.

In her series "American Icons" (1988–89), Carrie photographed household objects, such as cookie jars, salt and pepper shakers, and ashtrays, that showed African Americans in serving positions. In Untitled (Letter Holder), a photograph from this series, an African-American man is a porter, pushing a dolly with a suitcase that holds letters. The man's miniature size and lifelike presence on a desk make him appear funny at first. After a moment, though, the photograph becomes a chilling reminder of how often African Americans have been forced to wait on white people. It is also an example of the insulting way African Americans have been portrayed in images and objects of American popular culture.

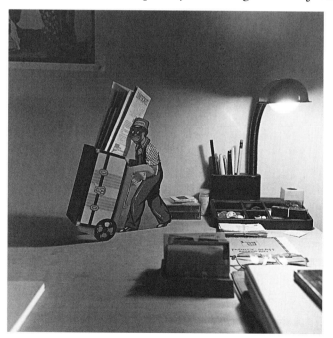

For "American Icons," Carrie used a larger camera with film having only twelve exposures. Her pictures had to be carefully planned. They could not have the informal and spontaneous appearance of her earlier work. This camera, called a two and a quarter (the negative is 2 1/4 inches square), was also Carrie's choice for another series, Untitled ("Kitchen Table Series") (1990).

Untitled, (Letter Holder), from "American Icons," 1988–89

In Untitled ("Kitchen Table Series"), Carrie planned twenty photographs that would tell a love story. She used herself as the main character but included a man, other women, and children. All the photographs were taken around a kitchen table with a dome-shaped light above it. The setting is like a stage on which a human drama is acted out.

Carrie wrote an unusual text to go with the photographs, using everyday language as well as rhymes and songs. She tells of a woman, thirty-eight years old, who falls in love and gives birth to a daughter but is unable to work out her relationship with her husband. "She felt like she was walking through a storm, like she was in a lonesome graveyard, like she had many rivers to cross," writes Carrie about the character. The woman and her husband could not agree on how each should act. She wanted him to accept her as his equal, "a 50-50 thing," Carrie explains. "He didn't mind a woman speaking her mind, but hey, she was taking it a tad too far," writes Carrie. Although they separate, the woman feels good about standing up for herself and looks to the future for better times. "Step on a pin, the pin bends and that's the way the story ends," writes Carrie.

In Untitled (Woman and Daughter with Make-up), which is a photograph from this series, Carrie, acting as the mother, puts on makeup with her character's daughter. They both use similar mirrors and lipstick. Because the daughter is too young to wear makeup, she appears to be imitating her mother.

Carrie arranged and photographed this scene to show how girls learn to be women. Although the viewer knows that the woman/mother in the story is trying to be a modern girlfriend, in this photograph she is also a traditional model for her daughter. Applying makeup becomes a symbol for womanhood and the ways in which girls sometimes grow up copying their mothers.

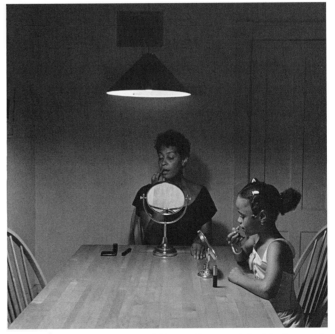

Untitled (Woman and Daughter with Make-up), from Untitled ("Kitchen Table Series"), 1990

47

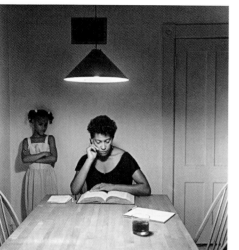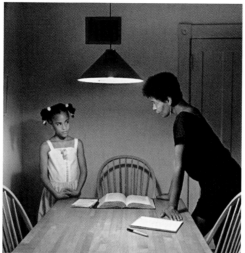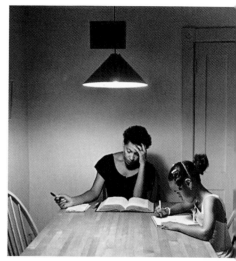

Untitled (Woman with Daughter), three photos, from Untitled ("Kitchen Table Series"), 1990

In Untitled (Woman with Daughter), a set of three photographs from Untitled ("Kitchen Table Series"), Carrie explores the tensions that can occur between a mother and child. As the mother sits at the table reading, her daughter stands in the background, arms folded, looking down, maybe wondering how to get her mother's attention. In the next photograph the mother and daughter seem to be having an argument. The mother looks stern. The daughter appears coy but angry. In the last picture they are both reading and writing. Perhaps they settled their conflict and found a way to be together.

Part of the text that accompanies these photographs and tells of the daughter's anger reads, "The kid had seen her parents loving and fighting, and had started playing house herself. She felt like H O T spelled more than hot . . . like Mother May I was too real to be called a game, like step on a crack and break your momma's back could be a plan, . . . like hide and seek may be the best bet, like boys were rotten just like cotton described every boy she knew, like girls were dandy like candy described her to a tee, like over the rainbow was where it was at, even though she didn't like flying . . ."

While Untitled ("Kitchen Table Series") shows an African-American family, these photographs do not speak exclusively of that culture. As in Untitled (Woman with Daughter), Carrie is concerned with issues that affect *all* families: how to raise a child, how to find the best way to be a family, and how to give and receive love.

In an exhibition in 1992, Carrie examined the Gullah culture. The Gullahs are blacks

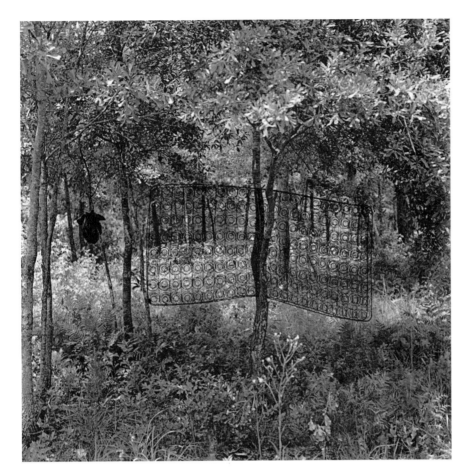

Untitled (Trees
with mattress
springs) from
Untitled ("Sea
Islands Series"),
1991–92

whose ancestors were slaves deported from West Africa to the Sea Islands off the coasts of
the Carolinas, Georgia, and northern Florida in the seventeenth and eighteenth centuries.
With photographs, stories, and even objects such as china plates, Carrie reveals the richness
of the Gullahs' history and present-day lives. She believes that the African culture influenced
the Gullahs and other African Americans in similar ways, particularly in language. On one
china plate, Carrie writes,

"Went looking for Africa and found it lurking quietly

along the shores of the Carolinas, the inland of Georgia,

the delta of Mississippi, the hills of Oakland,

the malls of Newark, the plateaus of Arizona."

Through her exploration of the Gullahs, Carrie searches for her roots and reclaims
her heritage.

Since her first exhibition in 1980, Carrie's art has been highly praised. Shown through-out the world, her carefully composed photographs fearlessly examine African-American lives. "Truth can be awfully ugly and awfully beautiful, too," Carrie says. At the same time that she teaches about African Americans, she inspires people of all races to reflect on their own lives. Often using text with her pictures, Carrie makes poetry from everyday language. The objects that sometimes accompany her work also provide another way of understand-ing her message. In all her art, Carrie expresses what it means to be African American. "It's not about me," says Carrie. "It's about us."

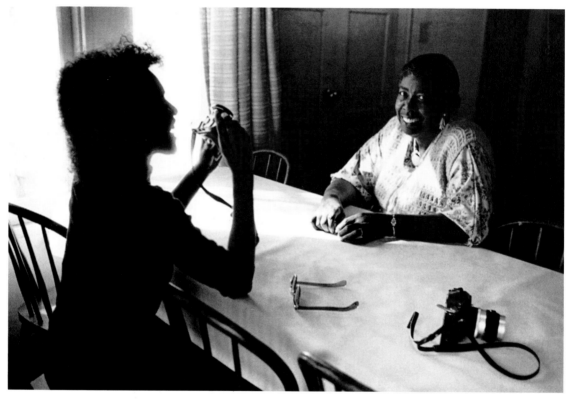

Untitled (Portrait Working)

Elsa Dorfman

1937–

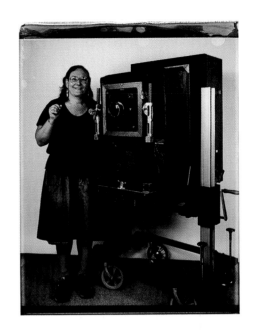

In grammar school, Elsa Dorfman could not sit still. Jumping up constantly with questions, she loved to talk with her teachers and schoolmates. At home in her courtyard apartment building, there were thirty children with whom she played. Often visiting her neighbors, she thought of them as family. The closeness and love she shared with people helped form her as a person and, years later, as a portrait photographer.

Elsa was born on April 26, 1937, in Roxbury, then a large Jewish neighborhood in Boston, Massachusetts. She thought she would be a writer. She loved to read and write stories. As a teenager, she wrote articles for her high-school paper and even had a column in the town paper. When she graduated from Tufts University in 1959, though, she moved to New York City with her friend Gail Gordon and worked at a publishing company called Grove Press.

At Grove Press, Elsa arranged readings for a revolutionary group of poets known as the Beats. The Beat poets challenged the way poetry had

Top: *Me and the camera, August 8, 1986*
Left: Untitled (Childhood Photo)
(middle child, top row)

been written. Before World War II, many American poets wrote about myth and history. They were more concerned with expressing ideas than exploring feelings. Their poems followed certain rules that had been used for generations and were based largely on European traditions. The Beats found these poems too impersonal.

The Beat poets were angry that their country had engaged in what they thought was a meaningless war. And they despised the commercial values and conformist attitudes of Americans in the 1950s following World War II. (They were called Beat, in fact, because they felt both beaten down and beatific, or extremely joyful.) They weren't going to follow any rules. They experimented with what they said and how they said it. They thought poetry should reflect everyday experiences and be full of emotion. Their poetry had the rhythms of speech and sometimes of popular music, especially jazz.

The work and opinions of the Beats influenced Elsa deeply. They became her friends, and one poet, Allen Ginsberg, became her guide. When unsure of herself, she would think, "What would Allen do?" Sometimes this helped, but it did not lead her to the creative life she wanted. After a year at Grove Press, Elsa returned home. Not knowing what to do, she entered graduate school to study elementary-school education. After graduating, she taught fifth grade in Concord, Massachusetts.

Although teaching was a popular profession for young women of Elsa's generation, Elsa found it did not suit her. She continued to arrange poetry readings and even had her poet friends read for her students, but she still was not happy. Luckily, one parent told her about an exciting company, Educational Development Center, or EDC, where people created learning materials for children. In 1964, Elsa left teaching to work in the science department of EDC.

EDC had a reputation for using great photography. A well-known photographer named Berenice Abbott had worked at EDC and used the darkroom to print the historic photographs of an important French photographer, Eugène Atget (pronounced AT-jay). Abbott's easygoing assistant, George Cope, had become the head of the photography department. He taught Elsa how to use a camera, develop the film, and print photographs. Elsa was thrilled.

Elsa, then twenty-eight, announced to her poet friends that she was a photographer. She thought they might laugh, but instead they asked her to take their portraits. Gordon Cairnie, owner of a famous poetry bookshop, The Grolier, and supporter of many poets,

invited Elsa to photograph his customers. Grove Press bought a portrait of one of its authors, Charles Olson, for the cover of his book, *Human Universe.* It was Elsa's first sale.

Being a photographer gave Elsa a sense of purpose. Using a small camera known as a 35 mm she walked throughout the city, photographing everyone who interested her.

She also photographed her friends and family in her home on Flagg Street in Cambridge. Elsa said that when she takes pictures of them, "I always have everybody. I don't have to worry about their going away." Her subjects inspired her, and the energy she shared with them was like the secret ingredient in a magical stew. With her camera in hand, she has explained, she might be thinking about where she should stand, whom she should include, and what details would make the picture interesting, but no one knows this. Her subjects feel as though they are just talking and having a good time with this warm, loving, and often humorous woman.

In *My sister Janie Power and her daughter Lizzy, Sept. 1973,* a Flagg Street portrait, Elsa did not arrange the setting or her subjects. She caught them in a common activity: a mother fixing her daughter's hair. They could be any mother and daughter, but Elsa handwrites

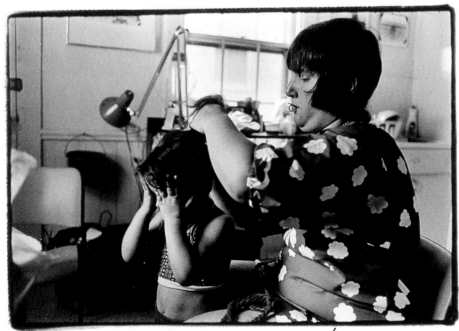

My sister Janie Power and her daughter Lizzie, Sept. 1973

their names and her relationship to them underneath the photograph to let the viewer know that they are close to her. The photograph, like Elsa's other portraits, invites the viewer to share her feelings for her subjects.

In the 1970s, many young photographers were concerned with abstract images or capturing the exotic. Elsa, though, thought her life a worthy photographic subject.

After nine years of photographing on Flagg Street, Elsa won a grant from the Bunting Institute at Radcliffe College to make a book of her pictures. *Elsa's Housebook: A Woman's Photojournal* was published by David Godine in 1974. The book contained not only Elsa's appealing photographs but also her writing, which introduced her friends and family and explained her thoughts on photography. Still, Elsa did not try to support herself taking pictures. No longer working at EDC, she edited articles and books as a way to get by.

Then, in 1976, Edwin H. Land, the inventor of the Polaroid camera, a camera that can develop a picture in seconds, announced a new Polaroid that could produce huge photographs—2 feet by 1 1/2 feet—in only 75 seconds. Because making this camera was so expensive, only five were ever built. The camera is an enormous rectangular wooden box that weighs 200 pounds and stands on a metal frame with wheels. A photographer can position a black pleated–cloth bellows to focus a huge lens that moves back and forth in front of the film. Inside, pods of chemicals develop the pictures. No spare parts were made. Dr. Land did not expect these cameras to be used commercially.

The cameras went to five cities throughout the world, including Boston. Dr. Land allowed established photographers to try it in exchange for some of the resulting photographs. In the winter of 1980, Elsa had her chance. She photographed poets Allen Ginsberg and Peter Orlovsky. She was supposed to take just ten pictures, but the results were so exciting, she took thirty.

She loved how large her subjects looked, with tiny, distinct details. The speed of the process and the bright white paper background made the photographs appear fresh and her sitters look friendly. The pictures seemed to her, in fact, similar to short stories. Like good fiction, they revealed all the particular qualities of a character. "How could I use this camera more?" Elsa wondered.

During the previous eighteen years, Elsa had photographed mostly people she knew. Now, if she wanted to continue to use the large Polaroid, she would have to rent it, which would mean she would need paying customers. Although starting a portrait business with this new and unusual camera seemed risky, Elsa decided to rent it one day a month.

To her surprise, her plan worked. The news spread about Elsa Dorfman, portrait photographer. People came to her not just because of the unusual camera. They liked Elsa's style. Elsa never posed her subjects or asked them to look or dress in any special way. Like her Beat poet friends, she was concerned with everyday life. She used the Polaroid to capture people just as they were. The resulting photographs glowed with goodwill.

Eventually Elsa was able to use the Polaroid full-time. Her portraits not only provided a way to make a living but also became an expression of her connection to people. Her clients most often know her work before they call. Entering Elsa's studio, they are greeted by three hundred portraits on her walls that seem to say, "You can do it, too!" Facial expressions, postures, and even clothing all give clues about what the people are like. As Elsa has said, though, "Portrait photographs aren't the whole person, the real person. Portraits seem true because we know the person had to have been there in front of the lens for the image to register on the film." The viewer "knows" the person by how the photographer chose to arrange the photograph. The relationship between the photographer and her subject also affects how much a subject is willing to reveal.

Sometimes a client will bring a favorite object, as in *Robbie and the Dinosaur Femur, November 12, 1990.* At age nine, Robbie traveled with his mother to a dinosaur dig. During the trip, he found a leg bone fragment of a young dinosaur. Robbie carefully braces it in its heavy plaster cast. He is proud of his find. The photograph, while a flattering portrait, also makes the viewer wonder who this boy is and how he got a dinosaur bone.

Pets, too, often become important characters in Elsa's work. In *Isaac and Ryan, May 16, 1984,* Elsa's son, Isaac, and his best friend, Ryan, show off Moozer and Snoopy. Because Elsa encourages suggestions from her subjects, she welcomed the boys' idea to include their dogs. The boys' affection for each other and their pets radiates from the picture. It is also an image of typical eight-year-old kids and their pets.

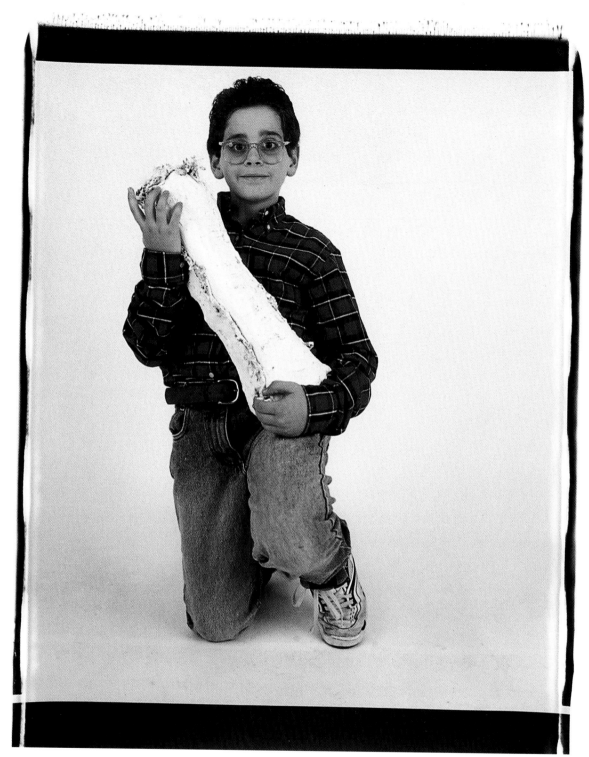

Robbie and the dinosaur femur. November 12, 1990

Robbie and the Dinosaur Femur, November 12, 1990

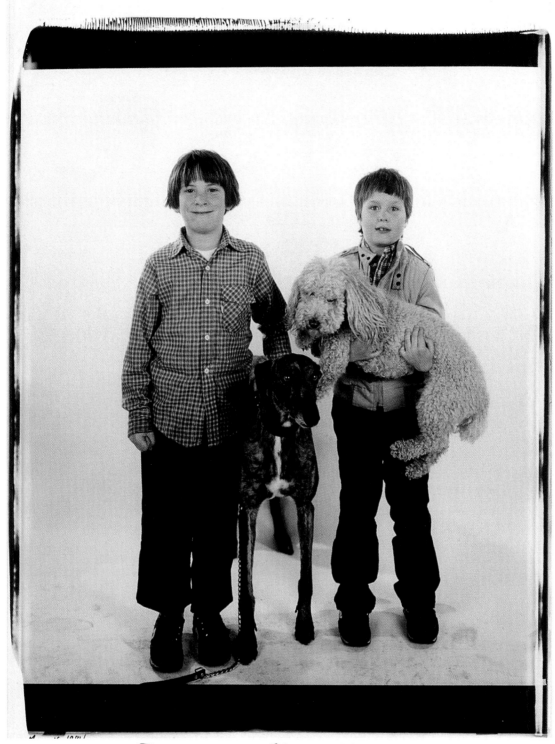

Isaac + Ryan. May 16, 1984.
Dafman

Isaac and Ryan, May 16, 1984

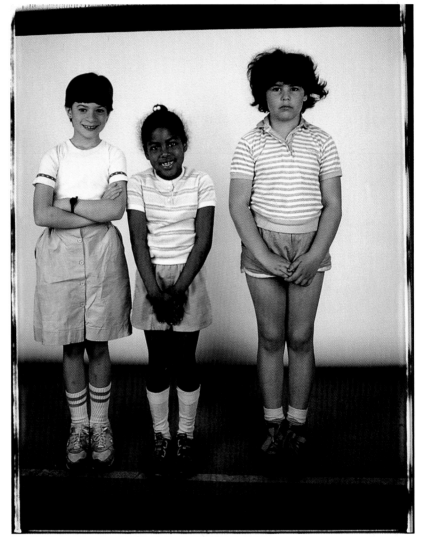

Chrissa, Requina, & Hillary Rm G14, May 23, 1985

Chrissa, Requina + Hilary. Rm G14. May 23, 1985

Throughout Isaac's grammar-school years, Elsa invited his classmates to her studio. *Chrissa, Requina, & Hillary Rm G14, May 23, 1985,* shows three girls from Isaac's third-grade class. Close friends, they asked to be photographed together, though they all exhibit different feelings. Chrissa, with her wide smile and folded arms, appears relaxed and friendly. Requina, shoulders bent forward, hands together, raised eyebrows, and wide grin, looks shy and giggly. Hillary, with one hand holding the other and seemingly afraid to smile, is perhaps cautious. In Elsa's portrait, these girls appear so present, you feel as though you know them—or would like to.

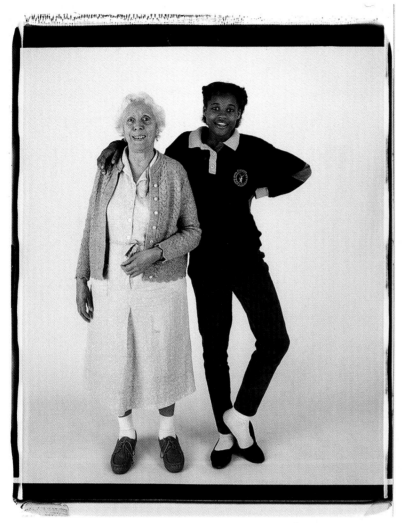

*Terri Terralouge and
Aileen Graham,
March 21, 1989*

Terri Terralouge and Aileen Graham. March 24, 1989.
Dorfman

In *Terri Terralouge and Aileen Graham, March 21, 1989,* friendship is again the subject. Terri, a nursing-home resident, met Aileen, a middle-school student, through a school computer club. Every Wednesday Aileen's class would travel to the Martin Nursing Home to teach the elderly how to use computers. The project, organized by the John Fitzgerald Kennedy Library, was so successful that they asked Elsa to document the new friendships that formed. Her pictures, known as the Grandparent Project, are a celebration of the bonds that can occur between generations.

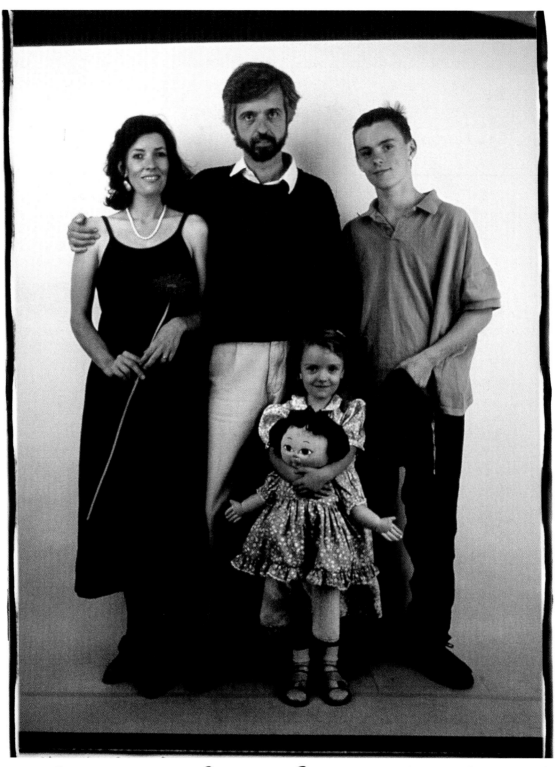

Felicia. Chris. Kara + Nick. On the Polaroid 20x24. September 3, 1986.

Taking photographs of celebrations is not unusual, but sometimes a photograph can provide healing, too. *Felicia, Chris, Kara & Nick On The Polaroid, 20x24, September 3, 1986,* was taken three weeks after this family survived a life-threatening car accident. Feeling blessed to be alive, they called Elsa. Meeting for the first time, Elsa and the Chadbournes talked for two hours before Elsa approached her camera. The portrait reflects not only the Chadbournes' presence in the world but also their togetherness as a family. The image was so powerful for them that when a grandfather died, they placed a small copy in his pocket before he was buried.

Using her natural ability to connect to people, Elsa Dorfman portrays individuals and families with a striking freshness. By encouraging people to be themselves, she makes the simple and ordinary become special. With her warm, straightforward, and funny ways, Elsa shares of herself and inspires others to do the same. In Elsa Dorfman's art, the goodness of people is evident.

Felicia, Chris, Kara & Nick On The Polaroid,
20x24, September, 3, 1986

Thats me, Thats me,

Thats me, Thats me,

Cindy Sherman

1954–

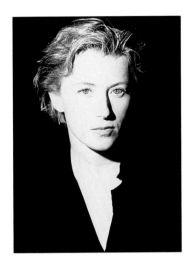

As the curtains were drawn open from a large picture window, Cindy Sherman, age six, appeared, dressed in a costume ready to perform. "The game of dress-up was an organized activity for me," she said years later. She kept a suitcase filled with party dresses and other clothes from thrift shops. She didn't want to be a bride or princess or ballerina like her friends. "I liked being a monster," she recalled. Playing with her nieces, she would distort her face with tape and rubber bands. Pretending to be unusual characters would become the way Cindy made art.

Cindy was born January 19, 1954, in Glen Ridge, New Jersey, but moved to Long Island, New York, when she was three. On Long Island she lived near the beach in a lush green hilly area with tiny winding roads and no sidewalks. In the summers, from early morning until after dark, she played with the neighborhood children, in bare feet and wearing only a bathing suit. She had lots of freedom to roam and explore.

Cindy's parents supported her creative activities. Her mother, Dorothy, was a teacher, and her father, Charlie, was an engineer and amateur inventor. Cindy's sister and three brothers were also creative. There were always art materials in their house.

Opposite page: Untitled (Thats Me), from *A Cindy Book*
Top right: Untitled (Portrait)

Drawing and painting were some of Cindy's favorite pastimes. She was often making something, even while watching television. She was best at copying things around her. Her pictures sometimes took hours, but they would end up looking perfectly realistic.

In high school, Cindy was praised for her artistic ability. While the praise embarrassed her, she gained a lot of confidence. She has said, though, "I didn't have the concept of what a real artist, or fine artist, was." She was attracted to cartoonists on boardwalks, courtroom illustrators, and face painters at fairs.

When she attended college at the State University of New York, Buffalo, in 1972, a photography professor helped Cindy understand how she could be an artist. She gave her a problem: to photograph something that made her feel uncomfortable. Cindy chose to photograph herself naked. While this was difficult, she learned that having *an idea* was most important, even more so than a technique. Although she was talented at copying with pencils and paints, those methods had not allowed her to express anything personal. With a camera, however, she could use her body as a tool. By posing, making facial expressions, and dressing up, Cindy could create unique images. Moreover, a camera would quickly capture any adjustments. She would have many copies from which to choose.

Cindy was excited by this discovery. With each new project, she developed her idea of using her own body as a model. Just as she had when she played dress-up as a child, she thought of ways to make herself look different.

In another assignment, Cindy pretended she was in a photo booth and took many head-and-shoulder pictures of herself. Each one showed her wearing more and more face makeup, until eventually she appeared to be a completely different person. It was fun "playing like that by yourself," she said. "You don't care if you look stupid." Cindy kept only the best pictures. "No one has to see your mistakes," she added.

When Cindy graduated, she knew she wanted to photograph herself as though she were an actress in a movie. She had already begun to create characters. She had, in fact, dressed up in costumes and taken photographs of herself, which she enlarged to life size, cut out, and pasted on cardboard like enormous paper dolls. She would place these cutouts in different scenes or make them appear to be talking or hugging.

She was also impressed by an odd French movie called *La Jetée (The Pier),* which she had watched at age twelve. Unlike a regular movie in which characters move and talk, this one was composed only of still photographs, with dialogue written below the pictures.

When Cindy moved to New York City in 1977, she brought along her costume col-lection, having added many more wigs, lots more makeup, and more costumes to it. Then on a visit to her parents in Arizona, she took her equipment and planned out a series of photographs called "Untitled Film Stills." (A film still is one frame from a motion picture.)

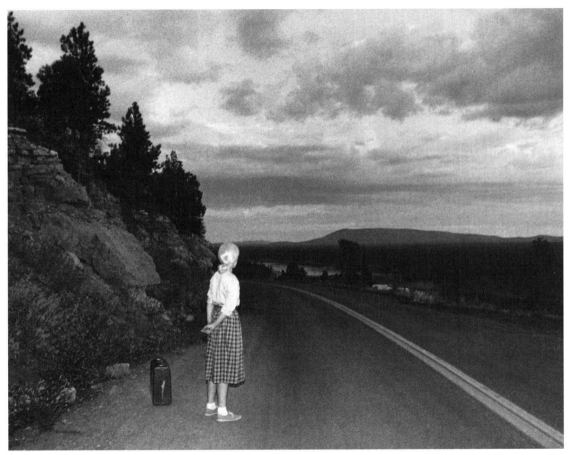

Untitled Film Still #48, 1979

Untitled Film Still #48 shows a girl facing away from the camera on an empty wind-ing road near a river and mountains. The girl, wearing her blond hair tied back at her neck, a long checked skirt, sneakers, and cuffed socks, is carrying an old-fashioned suitcase. She looks like a person from a past generation, perhaps the 1950s. The black-and-white tones and the bare landscape convey loneliness and make the viewer wonder why she is there. Is she waiting for someone? Is she running away? Light shining on the girl creates the effect of a scene from an old movie.

The girl, of course, is Cindy. The photograph was taken by her father following her instructions. Her father did not think it strange because, as Cindy said, "It was normal for me to be dressing up because I had been doing it since I was a kid." Together they created six photographs of the scene, but only this one captured the feeling Cindy wanted.

Besides wanting to have the photograph look as if it *might* be from a movie, Cindy was also interested in making the viewer guess what was going on. "I never want to spell things out so people are hit over the head with a message," she has said. Although *all* photographs can make the viewer question the subject, Cindy's photographs, with their set-up situations, can be particularly puzzling.

Her film-still pictures were quickly appreciated. Not only did art galleries want to exhibit them, but also the National Endowment for the Arts awarded grants to Cindy twice. The ways in which she developed her childhood interest in creating characters fascinated many people.

In 1981, an art magazine invited Cindy to create a series. She photographed herself in costumes, but this time, close-up, with mysterious expressions, and in color. Untitled #96 shows a young girl wearing an orange shirt, orange-and-white-checked skirt, and sneakers, lying on a linoleum floor. She is holding a ripped piece of newspaper and looks as if she is lost in thought. What has happened? Although the viewer doesn't really know, it is easy

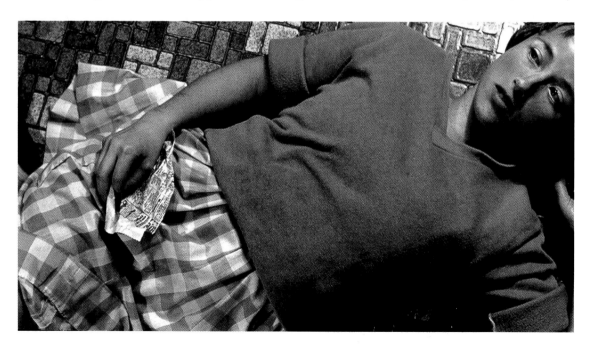

to imagine a story. Cindy explained, "I was thinking of a young girl who may have been cleaning the kitchen for her mother and who ripped something out of the newspaper, something asking, 'Are you lonely?' or 'Do you want to be friends?' or 'Do you want to go on vacation?' She's cleaning the floor, she rips this out, and she's thinking about it."

When Cindy sets up a scene, she places a mirror next to the camera to check herself. She's not pretending, however, to *feel* like a character. She has said, "It's more like a trance where I just visually try to change myself." Sometimes the best results come from accidents. Once she took many pictures, thinking she had captured the expression she wanted. Then the phone rang. She looked away. The camera went off automatically. That last picture turned out to be what she wanted. "For me," Cindy explains, "the only way to judge is when I actually look at the film."

Interest in Cindy's work increased, and in 1984, a designer asked Cindy to create photographs of herself wearing the latest fashions for a popular fashion magazine. Cindy

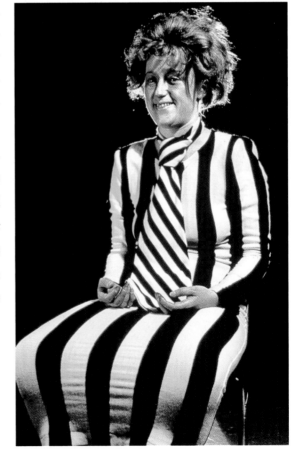

agreed, but just as she preferred to be a monster as a child, she chose to show the negative side of dressing in style. Cindy believes that women should not always try to look pretty or dress in a way that society expects. Untitled #138 supports her view. Here a tousled-haired woman with a ghoulish expression, sitting slumped, wears a comical black-and-white, wide-striped stretchy dress. A clownlike tie falls into her lap. Her hands rest on her thighs with palms upward and fingers that seem to have been dipped in blood. As Cindy expected, the fashion magazine rejected the photograph.

Opposite page: Untitled #96, 1981
Right: Untitled #138, 1984

Fairy tales have often been another source for Cindy's images. Untitled #143 shows Cindy dressed as a man lying on stones. His wounds, blackened complexion, and glazed eyes make one wonder if he has fallen in a battle. Is his head attached to his body? Even without knowing what has happened, the viewer gets a creepy feeling.

It is hard to imagine that it is the same person—Cindy—in all her photographs. From practicing copying in her drawings and paintings when she was a girl, Cindy learned how to model a form. As an adult, she used makeup in the same way to transform her face and body. "All my painting experience came in handy," she has explained. "It's really just a matter of using shadows, shading, and highlighting." Props help too, as well as lighting and other technical elements of photography.

Untitled #143, 1985

Untitled #173, 1987

After Cindy finishes a group of photographs, she studies them to see what might be missing and to decide how to proceed. She likes to give herself a problem. "I think a lot of times the best way I work is when I really have something to struggle with," she has said. In 1987, her challenge was to remove herself from the photograph's center, as in Untitled #173. The viewer is presented, instead, with an immense image, five feet by seven and one-half feet, of dark, glistening material, maybe dirt. Scattered about are enormous bugs, sticks, a discarded candy and its wrapper, a rounded form that might be a potato, and what looks like bloodied bits of fur. Stretched across the top is a woman with her cheek to the ground. Again one wonders what has happened. Has this woman fallen into garbage? Richly colored and textured material and debris gives this photograph the feeling of a painting. The blue-toned woman in the background, however, contrasts with the foreground and reminds the viewer that this is a mysterious photographic portrait.

Painting did inspire Cindy's work in 1989 and 1990. Looking at famous portraits, she created herself as painters' subjects. Because she likes to point out things some viewers don't want to see, Cindy emphasized ways in which many painters grossly altered their models. In some paintings, the subject's anatomy was completely inaccurate. In others, a portrait painter, who was paid a lot of money, would make an ugly person look beautiful. Often painters tried to hide the bored expressions of their sitters.

Untitled #224 is based on a portrait by sixteenth-century Italian painter Caravaggio. In it, Caravaggio used a mirror to paint himself as Bacchus, the Greek god of vineyards and wine. In her photograph, Cindy copies Bacchus' costume, gesture, facial expression, and even details such as his dirty fingernails and the dark circles under his eyes. Cindy looks a lot like Caravaggio's idea of Bacchus, but was she also imitating Caravaggio dressing up? The photograph asks the viewer in a humorous way to question who is modeling for such portraits.

Since Cindy first began to exhibit her work in 1976, her art has become known and collected all over the world. Using the childhood game of dress-up and her talents as a performer, makeup artist, costume and set designer, lighting specialist, and camera operator, Cindy has created photographs that make the viewer ask questions. For Cindy, the camera is a copying tool, a way to quickly capture a scene. Her scenes, however, are puzzles, intensely vivid set-up situations whose meanings reflect the *viewer's* thoughts, feelings, and fantasies. While Cindy's photographs suggest ideas about painting, films, storytelling, and women in society, they do not explain anything. With a quiet humor, Cindy Sherman creates art that makes us question the seeming truthfulness of photographs.

Opposite page:
Untitled #224, 1990

To the Readers

The works of the artists in this book represent only some of the ways in which photographs can be realized. Perhaps when you visit your next photography exhibit, you might guess what the photographer's intentions are. Is she trying to educate her audience, show a particular side of humanity, portray beauty, or make us laugh? Would her work be considered documentary, portraiture, abstract, or fantasy? Most importantly, what is the *feeling* you have when viewing the photograph?

Finding artistic photographs is not difficult. Many museums have photographic departments with photographs continually on display. In large cities, you may find an entire museum devoted to photography, such as the International Center for Photography in New York City. Galleries, too, often specialize in photographic work. And it is not unusual to find photographic exhibitions in libraries, concert halls, and schools.

If you think of a camera as an extension of your eyes and mind, you will see you can be a photographer, too. While it may not be as easy as a snap of the shutter to get the picture you want, with a little knowledge of the photographic process and the willingness to play, you can show the world what's real in your life.

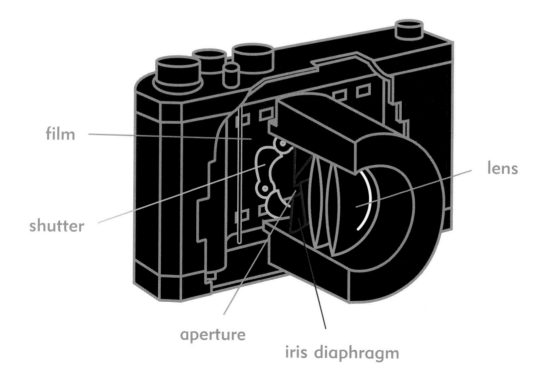

film

lens

shutter

aperture

iris diaphragm

Camera Basics

A **camera** (*camera* means *room* in Latin) is a chamber that records an image on a light-sensitive surface, such as **film**. Light passes through a curved disk made of plastic or glass known as a **lens**.

Behind the lens there is an **iris diaphragm**. This device is a series of blades that open and close to form an **aperture** or hole. The size of the aperture will determine the amount of light let in.

Behind the diaphragm and in front of the film is the **shutter**. The shutter is a movable screen that keeps all the light out until the moment the photograph is taken and a button or **shutter release** is pushed.

The length of time the light hits the film is called the **exposure**. If too much light is let in, the photograph will be **overexposed** and appear washed out or white. If not enough light is allowed, the result will be **underexposed** or dark.

In automatic cameras, there is a built-in **light meter** that gauges how much light is needed for a particular type of film. When the light meter registers that the light is too low, the camera will indicate that an additional light or **flash** is needed.

To make an image sharp, the photographer will need to **focus** the lens by moving it closer to or farther from the subject. The exposed film will also need to be moved so that a new unexposed piece will be in place. This is accomplished mechanically or sometimes manually by the photographer.

Lastly, cameras have **viewing systems,** devices that allow the photographer to see the subject through the camera and aim it properly. In **viewfinder** and **single-lens reflex** cameras, the photographer holds the camera at eye level and will capture the image just as she sees it in the viewer. In **twin-lens reflex** cameras, the viewing system is at the top of the camera, requiring the photographer to look down into the camera to see the subject. And in **view** cameras, the photographer views the subject at eye level, but the image in the camera is upside down and reversed.

Bibliography

General

Ancona, George. *My Camera.* New York: Crown Publishers Inc., 1992.

Ashe, Jeanne-Marie Moutoussamy. *Viewfinders: Black Women Photographers.* New York: Dodd Mead & Co., 1986.

Beaton, Cecil, and Gail Buckland. *The Magic Image: The Genius of Photography from 1837 to the Present Day.* Boston: Little, Brown & Co., 1975.

The Camera. Life Library of Photography. New York: Time-Life Books, 1970.

Davis, Duncan. "Photography." *Newsweek* (21 October 1974).

The Focal Encyclopedia of Photography. New York: McGraw-Hill, 1969.

Newhall, Beaumont. *The History of Photography from 1839 to the Present.* The Museum of Modern Art. New York: Little, Brown & Co., 1982.

———. *Photography: Essays and Images.* The Museum of Modern Art. Boston: New York Graphic Society Books, 1980.

Palmquist, Peter E., ed. *Camera Fiends and Kodak Girls: Fifty Selections by and about Women in Photography 1840–1989.* New York: Midmarch Art Books, 1989.

Pollack, Peter. *The Picture History of Photography.* New York: Harry N. Abrams, Inc., 1969.

Sullivan, Constance, editor. *Women Photographers.* New York: Harry N. Abrams, Inc., 1990.

Szarkowski, John. *Looking at Photographs—100 Pictures from the Collection of the Museum of Modern Art.* Greenwich, Conn.: New York Graphic Society, 1973.

Tucker, Anne, ed. *The Woman's Eye.* New York: Alfred A. Knopf, 1973.

Whelan, Richard. "Are Women Better Photographers than Men?" *Art News,* (October 1980).

———. *Double Take: A Comparative Look at Photographs.* New York: Clarkson N. Potter, Inc., 1981.

Imogen Cunningham

Dater, Judy. *Imogen Cunningham: A Portrait.* Boston: New York Graphic Society, 1979.

Margold, Jane. "Imogen Cunningham at 91: Still Developing." *Ms. Magazine* (February 1975).

Lorentz, Richard. *Imogen Cunningham: Ideas Without End*. San Francisco: Chronicle Books, 1993.

Mann, Margery. *Imogen Cunningham: Photographs 1910–1973*. Seattle: University of Washington Press, 1970.

Mozley, Anita V. "Imogen Cunningham." *Contemporary Photographers*. New York: St. Martin's Press, 1982.

Wiseman, Diane. "Imogen Cunningham 1883–1976." *Popular Photography*. Volume 79, Number 4 (October 1976).

Dorothea Lange

Cox, Christopher. *Dorothea Lange: Masters of Photography,* volume 5. New York: Aperture, 1981.

Elliot, George P. *Dorothea Lange*. The Museum of Modern Art. Greenwich, Conn.: New York Graphic Society LTD, 1966.

Hagen, Charles. "Soft-Focus Portraits Yield to Hard Images of Depression Poverty." *The New York Times,* Section C, Col. 1 (1 April 1994): 20.

Heyman, Therese Thau, Sandra S. Philips, and John Szarkowski. *Dorothea Lange: American Photographs.* San Francisco: Chronicle Books, 1994.

Lange, Dorothea, and Margetta Mitchell. *To a Cabin.* New York: Grossman Publishers, 1973.

Meltzer, Milton. *Dorothea Lange: A Photographer's Life.* New York: Farrar, Straus & Giroux, 1978.

———. *Dorothea Lange: Life Through the Camera.* New York: Puffin Books, 1985.

Newhall, Beaumont. *Dorothea Lange Looks at the American Country Woman.* Fort Worth: Amon Carter Museum, 1967.

———. *Masters of Photography.* New York: George Braziller, 1958.

Ohrn, Karin Becker. *Dorothea Lange and the Documentary Tradition.* Baton Rouge: Louisiana State University Press, 1980.

Partridge, Elizabeth. *Restless Spirit: The Life and Work of Dorothea Lange.* New York: Viking Press, 1998.

Riess, Suzanne. *The Making of a Documentary Photographer: An Interview.* Bancroft Library, Oral History Office, University of California, Berkeley: 1968.

Whiting, Sam. "Picture Perfect." *The San Francisco Chronicle* (15 May 1994): 32–34.

Lola Alvarez Bravo

Debroise, Oliver. *Lola Alvarez Bravo, In Her Own Light.* Tuscon: Center for Creative Photography, The University of Arizona, 1994.

Fernandez, Manuel. *Lola Alvarez Bravo: Recuentro Fotografico.* Mexico City: Editorial Penelope, 1982.

Grimberg, Salomón. *The Frida Kahlo Photographs.* Dallas: Barry Whistler Gallery, 1991.

Grimberg, Salomón. Interview with Lola Alvarez Bravo. Cuernavaca, Mexico, September 1989. (unpublished.)

Lola Alvarez Bravo, fotografias selectas, 1934–85. Centro Cultural Arte Contemporano, 1991.

Mulvey, Laura, and Peter Wollen. *Frida Kahlo and Tina Modotti.* Exhibition Catalogue. London: Whitechapel Art Gallery, 1982.

Naggar, Carole, and Fred Ritchin, ed. *Mexico Through Foreign Eyes, 1850–1990.* New York: W. W. Norton & Company, 1993.

Carrie Mae Weems

Kirsh, Andrea, and Susan Fisher Sterling. *Carrie Mae Weems.* Exhibition Catalogue. Washington, D.C.: The National Museum of Women in the Arts, 1993.

Princenthal, Nancy. "Carrie Mae Weems at P. P.O.W.," *Art in America* (January 1991).

Reid, Calvin. "Carrie Mae Weems," *Arts Magazine* (January 1991).

Sills, Leslie. Telephone interview with Carrie Mae Weems, 31 August 1994.

Tarlow, Lois. "Carrie Mae Weems," *Art New England* (August/September 1991).

Weems, Carrie Mae. Lecture. Duxbury Art Complex, Duxbury, MA, 1992.

Elsa Dorfman

Cohen, Joyce Tenneson. *In/sights: Self Portraits by Women.* Boston: David R. Godine, 1978.

Dorfman, Elsa. *Elsa's Housebook: A Woman's Photojournal.* Boston: David R. Godine, 1974.

Dorfman, Elsa. "Portfolio." *Ms. Magazine,* Vol. 4 (January 1976): 104–105.

Sills, Leslie. Conversation with Elsa Dorfman. Cambridge, MA, 17 June 1994.

Tarlow, Lois. "Elsa Dorfman—Polaroid Portraits" *Art New England* (June 1990).

Cindy Sherman

Barents, Els. Sherman interview, c. 1982; Introduction to *Cindy Sherman*. Munich,
 Germany: Schirmer/Mosel Publisher.

Kraus, Rosalind, and Norman Bryson. *Cindy Sherman 1975–1993.* New York: Rizzoli
 International Publications, 1993.

Philips, Lisa, and Peter Schjeldahl. *Cindy Sherman.* Exhibition catalogue. New York:
 The Whitney Museum of American Art, 1987.

Rosen, Randy. *Making Their Mark: Women Artists Move into the Mainstream, 1970–85.*
 New York: Abbeville Press, 1989.

Schjeldahl, Peter, and Micheal I. Danoff. *Cindy Sherman.* Exhibition catalogue. New York:
 Pantheon Books, 1984.

Sills, Leslie. Conversation with Cindy Sherman. New York, 20 September 1994.

Works by the photographers in this book can be viewed on the worldwide web:

Imogen Cunningham, Dorothea Lange, Lola Alvarez Bravo, Cindy Shermam
www.masters-of-photography.com
Dorothea Lange
www.lcweb.loc.gov/exhibits/wcf/wcf0013.html
Carrie Mae Weems
www.pbs.org/conjure/cm.html
Elsa Dorfman
www.elsa.photo.net

Index

Page numbers in italic type refer to photographs.

Abbott, Berenice, 52
African Americans
 Sharecroppers, Eutaw, Alabama
 (Lange), 26, *27*
 Weems, Carrie Mae, 5, 40, *41,*
 42–50, 47, 48, 50
 After Ninety (Cunningham), 15,
 17
Alvarez Bravo, Lola, 5, 31–39
 Anarquía arquitectónica de la
 ciudad de Mexico
 (Architectural Anarchy of
 Mexico City), 34, 35
 Paisaje fabricado (Man Made
 Landscape), 36, 36
 Por culpas ajenas (Due to the Fault
 of Others), 30, 31
 El sueño de los pobres 2 (The
 Dream of the Poor 2), 32, 32
 Tiburoneros (Shark Fishermen),
 38–39, 39
 The Two Fridas, 37, 37, 39
 Untitled (Self-Portrait), *31*
Alvarez Bravo, Manuel, 33, 34
Alvarez Bravo, Manuel, Jr., 33
"American Icons" (Weems), 46, *46*
Anarquía arquitectónica de la ciudad de
 Mexico (Architectural Anarchy of
 Mexico City), 34, 35
Architectural Anarchy of Mexico City
 (Anarquía arquitectónica de la
 ciudad de Mexico), 34, 35
Atget, Eugène, 52

The Beats (poetry group), 51–52, 54
The Black Photographers Annual, 45
Blessed Art thou Among Women
 (Käsebier), *6,* 7
Bunting Institute (Radcliffe
 College), 54

Cairnie, Gordon, 52–53
California Institute of the Arts, 45
The Camera (magazine), 8
Cameras, basics of, 75
Caravaggio, 73

Childhood Photo (Untitled)
 (Dorfman), *51*
Childhood photo, with brother,
 Martin (Untitled) (Lange), *19*
Chrissa, Requina, & Hillary Rm G14,
 May 23, 1985 (Dorfman), 58,
 58
Cope, George, 52
Corcoran Gallery (Washington,
 D. C.), 28
The Country Teacher (El Maestro
 Rural) (magazine), 34
Cunningham, Imogen, 5, *7,* 7–17
 After Ninety, 15, *17*
 Imogen Play Acting in Javanese
 Costume, 1910s, 10
 Leaf Pattern, Carmel Mission,
 before 1929, 12, 13
 Magnolia Blossom, 1925, 11, *11*
 Morris Graves, Painter, 1950,
 14–15, *15*
 My Father at Ninety, 1936, 16,
 17
 My Three Dolls, 1972, 17
 The Poet and His Alter Ego,
 1962, 13, 13–14
 Untitled (Self-Portrait with
 Camera), *7*
 The Wind, about 1910, 8, 9
Cunningham, Isaac, 8, 17
Curtis, Edward S., 8

Daddy with Kids, 1982–84 (Weems),
 44
DeCarava, Roy, 45
De Young Memorial Museum
 (San Francisco), 28
Dixon, Daniel, 22, 26
Dixon, John, 22, 26
Dixon, Maynard, 13, 22, 26
Documentary photography, Lange,
 19
Dorfman, Elsa, 5, *51,* 51–61
 Chrissa, Requina, & Hillary
 Rm G14, May 23, 1985,
 58, *58*

Elsa's Housebook: A Woman's
 Photojournal, 54
Felicia, Chris, Kara & Nick On
 The Polaroid, 20 x 24,
 September 3, 1986, 60, 61
Isaac and Ryan, May 16, 1984,
 55, *57*
Me and the camera, August 8,
 1986, 51
My sister Janie Power and her
 daughter Lizzy, Sept. 1973,
 53, *53–54*
Robbie and the Dinosaur Femur,
 November 12, 1990, 55, *56*
Terri Terralouge and Aileen
 Graham, March 21, 1989,
 59, *59*
Untitled (Childhood Photo), *51*
The Dream of the Poor 2 (El sueño de
 los pobres 2) (Alvarez Bravo), 32,
 33
Due to the Fault of Others (Por culpas
 ajenas) (Alvarez Bravo), *30,* 31
Dust Bowl, 22

Educational Development Center
 (EDC), 52
Elsa's Housebook: A Woman's
 Photojournal (Dorfman), 54

Fairy tales, 69
"Family Pictures and Stories"
 (Weems), *40,* 41, *42–44,* 45
Farm women, Lange, 28
Fashion photography, 69
Felicia, Chris, Kara & Nick On The
 Polaroid, 20 x 24, September 3,
 1986 (Dorfman), *60,* 61
Film und Foto (art exposition), 13
Flowers, Cunningham, 11, *11*
Folklore, Weems, 45–46

Gender relations, Cunningham's
 essay on, 8
Genthe, Arnold, 20
Ginsberg, Allen, 52, 54

Godine, David, 54
Gordon, Gail, 51
Grant, Cary, 14
Great Depression
 Cunningham, 14
 Lange, 19, 22–27
The Grolier (bookshop), 52
Group f/64, 13
Grove Press, 51, 52, 53
Guggenheim Fellowship, 15, 27
Gullah culture, 48–49, *49*

Human Universe (Olson), 53
Hurston, Zora Neale, 46

*Imogen Play Acting in Javanese
 Costume, 1910s,* 10
Isaac and Ryan, May 16, 1984
 (Dorfman), 55, *57*

Japanese internment camps, World
 War II, *27,* 27–28
La Jetée (The Pier) (film), 64
John Fitzgerald Kennedy Library, 59

Kahlo, Frida, 37, *37,* 39
Käsebier, Gertrude, *6, 7*
"Kitchen Table Series" (Untitled)
 (Weems), 46–47, *47,* 48, *48*
Korean Child (Untitled) (Lange), 28,
 29

Land, Edwin H., 54
Lange, Dorothea, 5, 13, 14, *18, 19,*
 19–28, 45
 *May 8, 1942, Hayward,
 California,* 27, *27,* 28
 Migrant Mother, 24, *25,*
 26
 "Migrant Mother",
 (three photos), 24, *24–25,* 26
 Sharecroppers, Eutaw, Alabama, 26,
 27
 Untitled (Childhood photo,
 with brother, Martin), *19*
 Untitled (Korean Child), 28, *28*
 Untitled (Migrant Housing,
 California, c. 1936), 23, *23*
 Untitled (Portrait on car roof
 with camera), *18*

Untitled (Raentsh Portrait, SF),
 21, *21*
*Leaf Pattern, Carmel Mission, before
 1929* (Cunningham), 1*2,* 13
Letter Holder (Untitled) (Weems),
 46, *46*
Life magazine, 28

*El Maestro Rural (The Country
 Teacher)* (magazine), 34
Magnolia Blossom, 1925
 (Cunningham), 11, *11*
*Man Made Landscape (Paisaje
 fabricado),* (Alvarez Bravo), 36,
 36
May 8, 1942, Hayward, California
 (Lange), 27, *27,* 28
Me and the camera, August 8, 1986
 (Dorfman), *51*
Mexican Revolution of 1910, 31
Migrant Housing, California c. 1936
 (Untitled) (Lange), 23, *23*
Migrant Mother (Lange), 24, *25,* 26
"Migrant Mother, Nipomo,
 California, 1936" (three
 photos) (Lange), 24, *24–25,* 26
Mom at Work (Weems), 40, *41*
Morris Graves, Painter, 1950
 (Cunningham), 14–15, *15*
Museum of Modern Art (New York
 City), 28
My Father at Ninety, 1936
 (Cunningham), 16, *17*
*My sister Janie Power and her
 daughter Lizzy, Sept. 1973*
 (Dorfman), 53, *53–54*
My Three Dolls, 1972 (Cunningham),
 17

National Institute of Fine Arts
 (Mexico), 39
National University of Mexico, 36
Nudity
 Cunningham, 10
 Sherman, 64
Nutzhorn, Dorothea Margaretta. *See*
 Lange, Dorothea
Nutzhorn, Henry, 20
Nutzhorn, Joan, 20
Nutzhorn, Martin, *19,* 20

Olson, Charles, 53
Orlovsky, Peter, 54
Orozco, José Clemente, 33

*Paisaje fabricado (Man Made
 Landscape)* (Alvarez Bravo), 36,
 36
Partridge, Gryffyd, 8
Partridge, Padriac, 10
Partridge, Roi, 8, 10, 14
Partridge, Rondal, 10
*Photographer's Association of
America Annual* (magazine), 8
The Pier (La Jetée) (film), 64
Plants, Cunningham, 11, *11, 12,* 13
The Poet and His Alter Ego, 1962
 (Cunningham), *13,* 13–14
Polaroid camera, 54–55
*Por culpas ajenas (Due to the Fault of
 Others)* (Alvarez Bravo), *30,* 31
Portait (Untitled) (Sherman), *63*
Portrait on car roof with camera
 (Untitled) (Lange), *18*
Portrait Working (Untitled)
 (Weems), *50*

Radcliffe College, 54
Raentsh Portrait, SF (Untitled)
 (Lange), 21, *21*
Rivera, Diego, 33
*Robbie and the Dinosaur Femur,
 November 12, 1990* (Dorfman),
 55, *56*
Roosevelt, Franklin D., 22, 23

"Sea Island Series" (Untitled), *49*
Self-Portrait (Untitled) (Alvarez
 Bravo), *31*
Self-Portrait with Camera
 (Untitled) (Cunningham), *7*
Sharecroppers, 26, *27*
Sharecroppers, Eutaw, Alabama (Lange),
 26, *27*
Shark Fishermen (Tiburoneros)
 (Alvarez Bravo), 38–39, 39
Sherman, Charles, 63
Sherman, Cindy, 5, *62,* 63–73, *63,
 65, 66, 67, 68, 69, 70*
 Untitled #96, 66, *66,* 67
 Untitled #138, 67, *67*

Untitled #143, 68, *68*
Untitled #173, 70, 69, *69*
Untitled #224, 70, *71*
Untitled Film Still #48, 65–66, *65*
Untitled (Portrait), *63*
Untitled (That's Me), *62*
Sherman, Dorothy, 63
Siqueiros, David Alfaro, 33
State University of New York, Buffalo, 64
El sueño de los pobres 2 (The Dream of the Poor 2) (Alvarez Bravo), 32, *32*

Taylor, Katherine, 26
Taylor, Margot, 26
Taylor, Paul, 14, 22, 23, 26, 28
Taylor, Ross, 26
Television, Lange, 28
Terri Terralouge and Aileen Graham, March 21, 1989 (Dorfman), 58, *58*
That's Me (Untitled) (Sherman), *62*
Tiburoneros (Shark Fishermen) (Alvarez Bravo), *38-39*, 39
Tracy, Spencer, 14
Trees with mattress springs (Untitled) (Weems), *49*
The Two Fridas (Alvarez Bravo), 37, *37*, 39

University of California, Berkeley, 45
University of California, San Diego, 45
Untitled (Childhood Photo) (Dorfman), *51*
Untitled (Childhood photo, with brother, Martin) (Lange), *19*
Untitled Film Still #48 (Sherman), *65*, 65–66
Untitled ("Kitchen Table Series") (Weems), 46–47, 48
Untitled (Korean Child) (Lange), 28, *28*
Untitled (Letter Holder) (Weems), 46, *46*
Untitled (Migrant Housing,

California, c. 1936) (Lange), 23, *23*
Untitled (Portrait) (Sherman), *63*
Untitled (Portrait on car roof with camera) (Lange), *18*
Untitled (Portrait Working) (Weems), *50*
Untitled (Raentsh Potrait, SF) (Lange), 21, *21*
Untitled ("Sea Island Series") (Weems), *49*
Untitled (Self Portrait) (Alvarez Bravo), *31*
Untitled (Self Portait with Camera) (Cunningham), 7
Untitled #96 (Sherman), 66, *66*, 67
Untitled #138 (Sherman), 67, *67*
Untitled #143 (Sherman), 68, *68*
Untitled #173 (Sherman), 69, *69*
Untitled #224 (Sherman), 70, 71
Untitled (That's Me) (Sherman), *62*
Untitled (Tree with mattress springs) (Weems), *49*
Untitled (Woman and Daughter with Make-up) (Weems), 47, *47*
Untitled (Woman with Daughter) (Weems), 48, *48*

Vanity Fair (magazine), 14
Vera and Van with Kids in the Kitchen (Weems), 41, *42–43*

Weems, Carrie Mae, 5, 40, *41*, 42–50, *47, 48, 50*
"American Icons," 46, *46*
Daddy with Kids, 1982–84, 44
"Family Pictures and Stories," *40*, 41, *42–44*, 45
Mom at Work, 40, 41
Untitled ("Kitchen Table Series"), 46–47, 48
Untitled (Letter Holder), 46, *46*
Untitled (Portrait Working), *50*
Untitled ("Sea Island Series"), *49*
Untitled (Tree with mattress springs), *49*
Untitled (Woman and Daughter

with Make-up), 47, *47*
Untitled (Woman with Daughter) (three photos), 48, *48*
Vera and Van with Kids in the Kitchen, 41, *42–43*
Whitney Museum of American Art (New York City), 28
The Wind, about 1910 (Cunningham), 8, *9*
Woman and Daughter with Make-up (Untitled) (Weems), 47, *47*
Woman with Daughter (three photos) (Untitled) (Weems), 48
Works Progress Administration (WPA), 22
World War II
The Beats (poetry group), 52
Japanese internment camps, *27*, 27–28